IMAGES
of America

LINCOLN

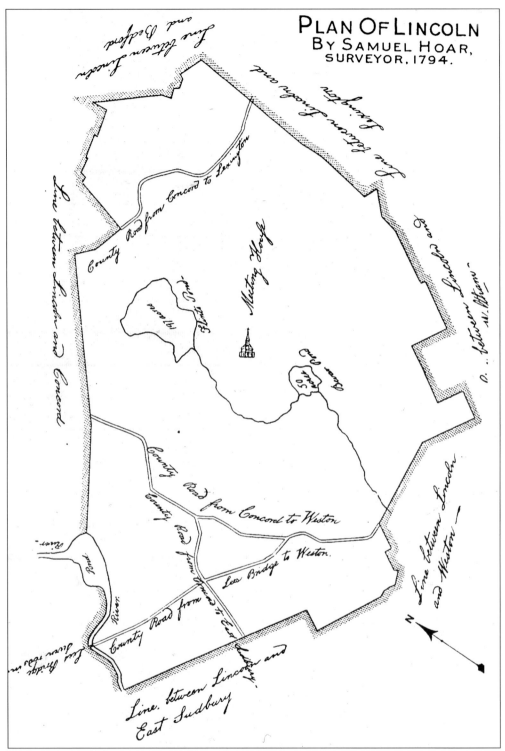

PLAN OF LINCOLN
BY SAMUEL HOAR,
SURVEYOR, 1794.

Forty years after the incorporation of Lincoln, the official map of the town showed that there had been little development in the intervening years. (Courtesy of the Lincoln Public Library.)

2

IMAGES
of America

LINCOLN

Lincoln Historical Society

ARCADIA

First printed in 2003.

Published by Arcadia Publishing,
an imprint of Tempus Publishing Inc.
2A Cumberland Street
Charleston, SC 29401

Printed in Great Britain.

Library of Congress Catalog Card Number: 2002112251

For all general information, contact Arcadia Publishing:
Telephone 843-853-2070
Fax 843-853-0044
E-mail sales@arcadiapublishing.com

For customer service and orders:
Toll-free 1-888-313-2665

Visit us on the Internet at www.arcadiapublishing.com.

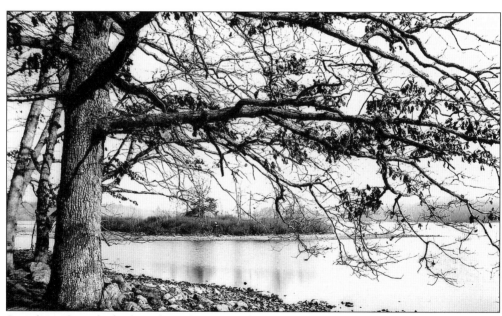

Seen here through the branches of a great oak tree, Flint's Pond was often visited by Henry David Thoreau, who recalled, "I stood amid the witch-hazels near Flint's Pond, a flock of a dozen chickadees came flitting and singing about me with great ado . . . [a] most cheery and enlivening sound." (Photograph by Herbert Gleason, courtesy of the Concord Free Public Library.)

CONTENTS

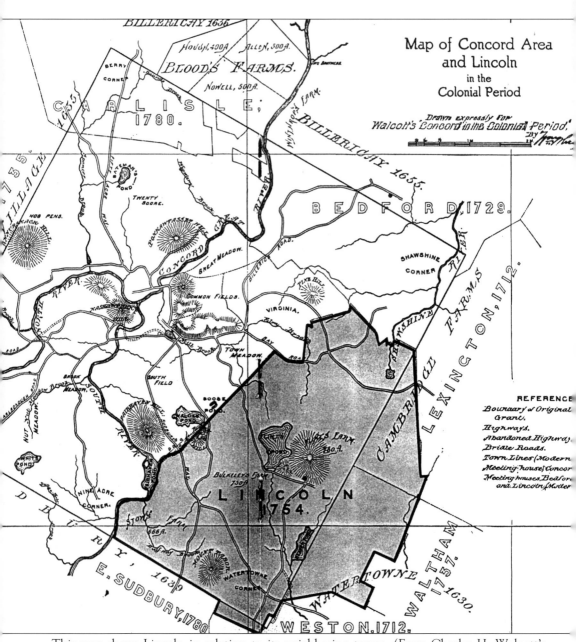

This map shows Lincoln in relation to its neighboring towns. (From Charles H. Walcott's *Concord in the Colonial Period*.)

INTRODUCTION

In December 1877, the *Boston Evening Record* held a contest that invited readers to submit essays describing the towns in which they lived. One of them was by Rev. Henry J. Richardson, pastor of the First Parish in Lincoln. Richardson wrote, "Few towns within the same radius from Boston have land of as good quality . . . a greater variety of trees . . . a unique character and beauty . . . [a] lake of excellent quality [Forest Lake, now Flint's Pond] . . . and [a] landscape equaled in few and surpassed in none of the towns of the region."

A visitor to Lincoln today will find few changes from the town that Richardson described. High on the summit between the valleys of the Charles and Concord Rivers, Lincoln still has an agricultural flavor and is home to the Codman Community Farm and the Food Project. It is more rural than suburban in feeling—with acres of conservation land and open fields, as well as miles of hiking and cross-country ski trails—and yet all of its natural beauty is a mere 16 miles from the city of Boston. Found within Lincoln's boundaries are Minuteman National Park, the headquarters of the Massachusetts Audubon Society and its educational component, Drumlin Farm; the DeCordova Museum and Sculpture Park; the Thoreau Institute; and the Gropius and Codman Houses, both owned by the Society for the Preservation of New England Antiquities.

We owe this legacy to the forefathers of Lincoln: to the farmers who worked the land and to the gentry. Richardson called the gentry "the best society" and described them as "intelligent, upright, kindhearted and given to neighborly offices." Included in this group are Bemis, Tarbell, and the widow of Prof. John Farrar of Harvard University, who built the town hall, donated the Lincoln Public Library, and endowed the library with a valuable collection of books, respectively. The Codmans, the Storrows, the Conrad Hatheways, and the DeCordovas were patrons of art, music, literature, and architecture. The post–World War II generation cherished this inheritance, preserved agricultural lands, and pioneered open-space and land-use management projects that are now often used as blueprints for other towns across the United States.

With this book and its photographs of Lincoln's people, farms, buildings, pastimes, celebrations, and natural resources, the Lincoln Historical Society hopes to impart the town's story and its preserved heritage. Some 128 years ago, Richardson wrote, "The grandchildren of men who find constant satisfaction in the natural beauties of the town will probably see the day when these rounded heights will virtually be the West End of Boston." His prediction has not come true, and Lincoln's many-faceted beauty lives on.

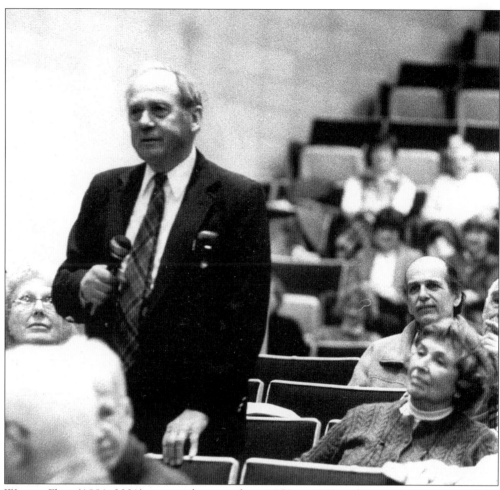

Warren Flint (1891–2001), town selectman from 1958 to 1963 and executive secretary of the board of selectmen from 1963 to 1975, has exemplified service to the town and to individual residents' concerns. He is shown addressing a town meeting. His wife, Margaret Flint, is to the right. Flint was the touchstone of Lincoln's land-use conscience. The Lincoln Historical Society gratefully dedicates this book to Lincoln's men and women for their guidance and leadership over the past 250 years. (Photograph by Norman Hapgood.)

One
HISTORICAL LEGACY

It is thought that Nathan Brown Sr. built the left side of this early house on land received from the Flint grant in the 1730s. At 30 Tower Road, it stands above the brook that divided the Bulkeley and Flint grants. Pierce Hill Road was originally a dam for the millpond of a sawmill, essential for the production of timber used to develop the land for settlement. (Photograph by Harriet Forbes, courtesy of the American Antiquarian Society.)

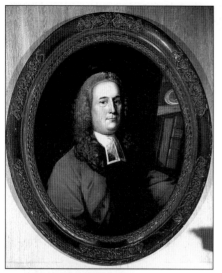

Chambers Russell, Lincoln's most prominent citizen in the Colonial period, named Lincoln after his ancestral home in Lincolnshire, England. In 1746, he was appointed judge of the Middlesex Court of Common Pleas. He became judge of the Court of Voice Admiralty in 1747. In 1752, he was named a judge of the Superior Court. He was also frequently a representative to the General Court, first for Concord and then from Lincoln. (Courtesy of the Massachusetts Audubon Society.)

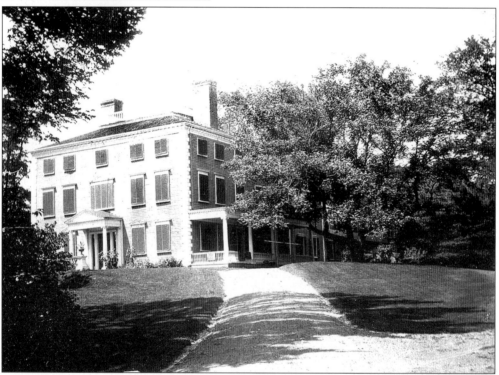

The Chambers-Russell-Codman House is shown here. Charles Chambers purchased a large section of the Bulkeley grant and added Barrett's meadow to his holding, where he built the core of this house c. 1738. His grandson Chambers Russell married Mary Wainwright, a descendant of Gov. Thomas Dudley. The Russells were childless, and the land and house were inherited by Russell's nephew Dr. Charles Russell, a Loyalist. Dr. Russell's brother Chambers Russell II acquired the house but died young, leaving it to John Codman, the husband of his sister Margaret. Now known as the Codman House, it is owned by the Society for the Preservation of New England Antiquities. (Courtesy of the Society for the Preservation of New England Antiquities.)

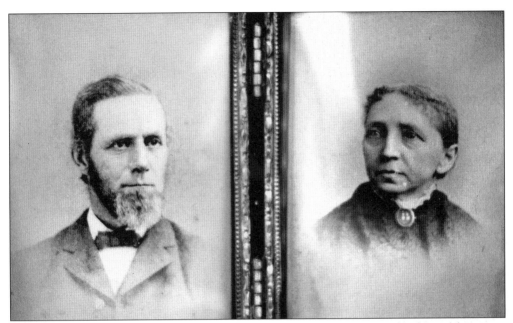

George Flint, in the sixth generation from Thomas, married Caroline Rice, daughter of the tavern keeper on the hill. The couple is shown here. George Flint divided the farm between their two sons—Edward, whose family continued to live on the homestead, and Ephraim, who received a new house across the road. The farm was known as Flint Brothers Farm. Edward was in charge of the greenhouses, and Ephraim ran the dairy. (Courtesy of the Flint family collection.)

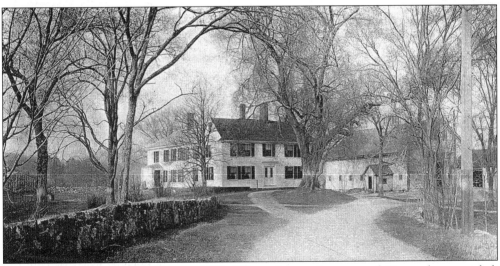

The Flint homestead dates from *c.* 1700. When the nearby town of Concord was settled, Thomas Flint, a prominent settler and large investor, received a grant in eastern Concord that consisted of 750 acres and a pond. The family lived in Concord village and hired an overseer to manage the farm. Ephraim, the son of Thomas, married Jane Bulkeley. When Jane Bulkeley died, Ephraim joined his nephew Edward on the Flint farm. When Ephraim died in 1724, he left the core of this house to his nephew Ephraim, and the house has continued to be owned by members of the Flint family. (Courtesy of the Lincoln Public Library.)

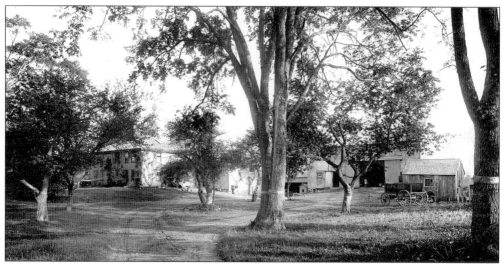

Pictured is the Thomas Garfield compound. In 1712, Capt. Benjamin Garfield of Watertown bought 120 acres on the Watertown-Concord line for his son Thomas, near where his sister Anna, the wife of Dea. Benjamin Brown, resided. Thomas Garfield in turn willed the compound to his son Thomas Garfield Jr. The younger Thomas had two sons: Solomon, who settled in New York State, and Abraham, who lived only four months after serving as a minuteman in the Revolutionary War battle of April 19, 1775. The Garfields were the ancestors of James Abraham Garfield, who served as president of the United States. When the house burned in 1943, it was no longer in the family. (Courtesy of the Lincoln Public Library.)

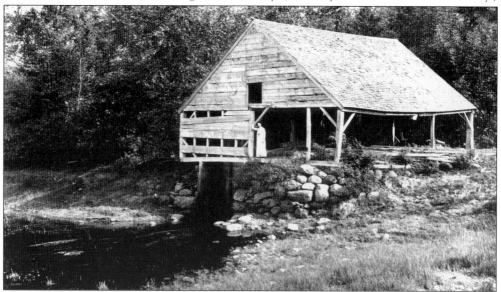

The Garfield-Jenkins-Harrington sawmill is pictured here. In 1758, Elisha Garfield, a son of Benjamin Garfield, settled on Garfield land along Stony Brook and constructed a mill. The property was subsequently sold to Thomas Jenkins Jr., who sold it to George F. Harrington. Harrington's 1866 tally book lists corn and rye ground for Coburns, Wheelers, and Codmans, and conjugal visits of his cows to Codman bulls. After the mill burned c. 1930, its surviving metal parts went to a World War II scrap drive. Two of its millstones are in the garden of a home on Tower Road. (Courtesy of the Society for the Preservation of New England Antiquities.)

This early house sits on the Stow grant, which was owned jointly by Daniel Dean and Thomas Goble. Daniel Dean was childless, and his share of the grant was inherited by Joseph and Daniel Adams, the children of his second wife, Margaret Eames Adams. Later, when the road became the Fitchburg Turnpike, the house (at 159–165 South Great Road) became an inn and tavern. In this photograph, the house is partly obscured by foliage. (Photograph by Harriet Forbes, courtesy of the American Antiquarian Society.)

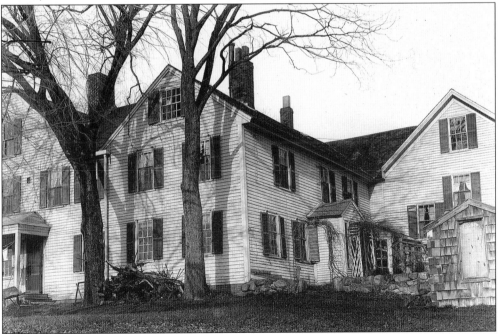

This rear view of the early Stow grant house shows a shingled shed, constructed to protect the water well. (Photograph by Harriet Forbes, courtesy of the American Antiquarian Society.)

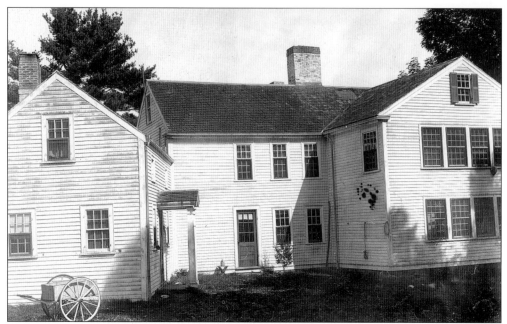

No longer visible from the road, the rear section of the house at 191 Concord Road is thought to have been built by Daniel Dean in the early 18th century, around the time that he was laying out the road from Concord to Sudbury. (Photograph by Harriet Forbes, courtesy of the American Antiquarian Society.)

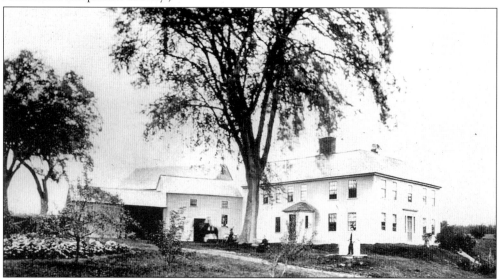

By 1809, the house at 191 Concord Road, the home of Capt. Charles Adams Wheeler, reflected an addition of rooms to the front. At one time, there was a steep gravel slope to the left of the house (now at the intersection of Routes 117 and 126), and the road often flooded in the spring. It was eventually necessary to raise the level of the road. Selectman John F. Farrar talked the owner of the house at the time, Helen Bateman, into letting gravel from her hill be used to improve the roadbed. John Farrar's cousin Edward Farrar also dammed part of his land, forming Farrar Pond. To benefit the landscape, a grove of trees was planted along the road. (Photograph by Harriet Forbes, courtesy of the American Antiquarian Society.)

Edward Farrar, creator of Farrar Pond, may accurately be said to have been Lincoln's first preservationist. Farrar brought Charles Foreman to Lincoln to work for him. Foreman, a member of the Cherokee Indian tribe who was born in Indiana, had attended carpentry school. Farrar gave him land to build a house for his family at what is now 147 South Great Road. After Farrar finished his plans for a dam and reassured his neighbors in both Concord and Lincoln of its safety, Foreman and Farrar together built the 250-foot dam. Pole Brook water was diverted to maintain the water level, and Farrar Pond was created. (Courtesy of the Lincoln Public Library.)

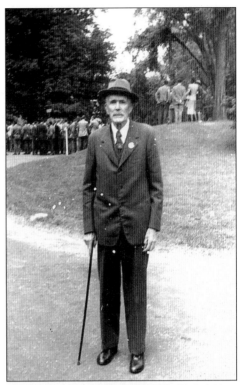

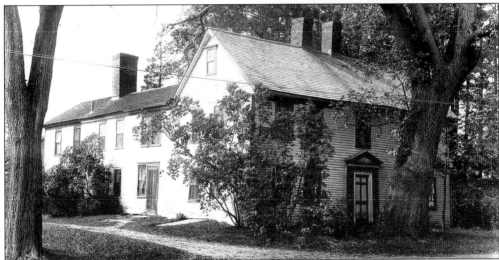

The Farrar homestead had a long history. During an attack on settlers in Lancaster in 1675, George Farrar's father was killed by Native Americans. Young Farrar was apprenticed by his mother to the childless Dean family of Concord. George had an inheritance; he was hardworking and thrifty as well. By the time of his death, he had acquired more than 1,000 acres. His descendants were prominent in Lincoln from the days of the Revolutionary War to the 20th century. Among the leadership roles they held were selectmen and church deacons. In the 1960s, the house had deteriorated badly and was razed. The woodwork of an upper chamber that was salvaged is now part of the Winterthur Museum collection. (Photograph by Harriet Forbes, courtesy of the American Antiquarian Society.)

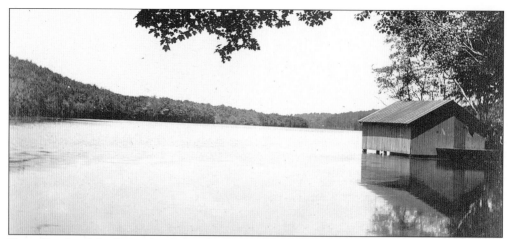

Farrar Pond and the Farrar family boathouse are depicted in this view. (Courtesy of the Lincoln Public Library.)

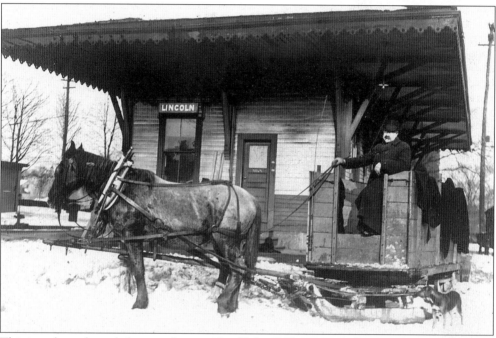

This is perhaps the only known photograph of John F. Farrar, Lincoln's best-known politician. He is driving a pung (a box on runners) that served as an early school bus. Farrar, said Sumner Smith, was a very colorful gentleman. He served many terms as town selectman. When in the legislature, he got in with a fast crowd. He was invariably seen smoking a cigar or pipe and is said to have never turned down a drink. "Mr. John," as he was known, got votes not only for himself but for others. He frequented the Higginson estate with the intention of engaging the votes of its many employees. When citizens at a town meeting were about to refuse the gift of Pierce House, Farrar explained that since they had accepted the gifts of Mr. Tarbell and Mr. Bemis, they should now accept the gift of Mr. Pierce, and they did. Sumner Smith remembered his father saying that of all the men he served with on the board of selectmen, Mr. John, drunk or sober, had the best judgment. (Courtesy of the Lincoln Public Library.)

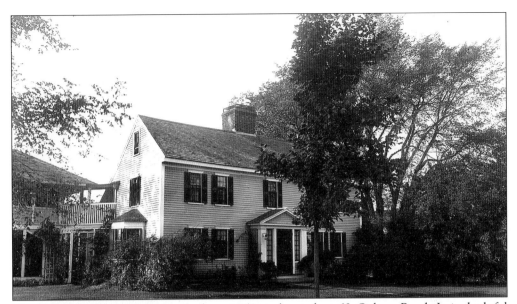

The Jonathan Sherman house, built *c.* 1753, is located at 62 Oxbow Road. It is doubtful whether Sherman knew that half of his house was in the town of Sudbury and the other half in Lincoln. Several requests to draw the town line with his house in Sudbury (where many of his relatives lived) were denied. Later, Sudbury was split into two towns. The original center was called East Sudbury, and the other half became Wayland. (Photograph by Harriet Forbes, courtesy of the American Antiquarian Society.)

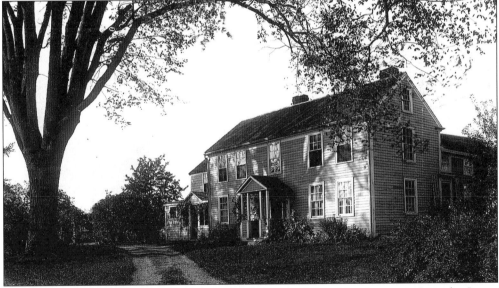

The Samuel Abbott House, at 59 Oxbow Road, is one of the oldest houses in Lincoln. It was built on land that Samuel Abbot bought from Daniel Dean in 1708. Since then, it has known many other owners and has undergone much alteration, including perhaps even being moved to a more substantial foundation. When this photograph was taken, the house belonged to the Robert Hunter family. Robert Hunter and his wife had two daughters: Elizabeth Hunter, whose married name became Doherty, and Jessie Hunter, who later worked as a telephone operator in Lincoln. (Photograph by Harriet Forbes, courtesy of the American Antiquarian Society.)

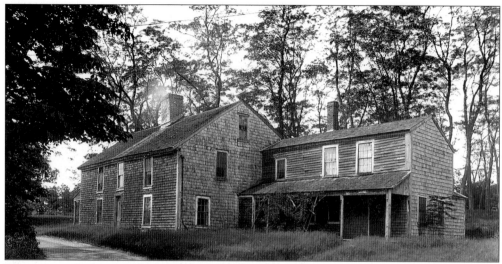

When it was built in 1702, the Benjamin Brown House (now at 15 Conant Road in Lincoln) was located in Weston. The original Watertown grant met the six square grant of Concord. Benjamin Brown was the grandson of Abraham Browne, whose house still stands in Watertown. A deacon in the Weston Church, Brown wrote a letter to the Massachusetts General Court in support of the precinct. The House of Representatives approved the precinct, April 26, 1746. It directed that Benjamin Brown, one of the principal inhabitants of the parish that lay partly in Concord and partly in Weston and Lexington, call a first precinct meeting to choose officers and to do all things according to law. (Photograph by Harriet Forbes, courtesy of the American Antiquarian Society.)

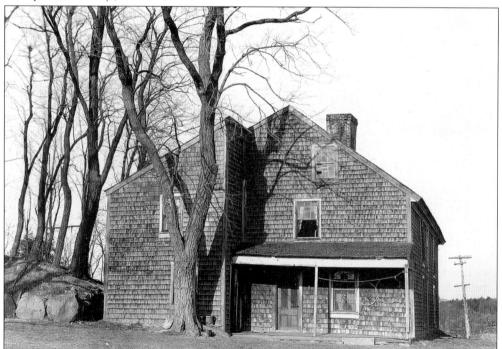

This side elevation view shows the massive rock outcropping behind the Benjamin Brown House. (Photograph by Harriet Forbes, courtesy of the American Antiquarian Society.)

The Hartwell Tavern sign is now displayed at the Buckman Tavern, owned by the Lexington Historical Society. Located on the North County Road, the Hartwell Tavern is in Minuteman National Park. The sign (now badly weathered) depicts a horse and rider on the opposite side. (Courtesy of the Lexington Historical Society.)

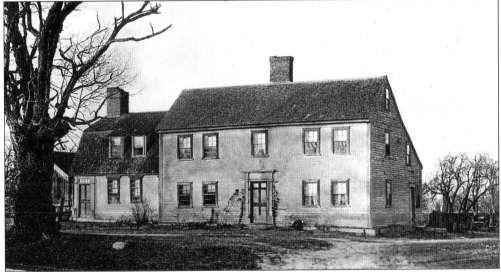

When Ephraim Hartwell married Elisabeth Heywood in 1732, his father, Samuel Hartwell, gave him a house on 30 acres next to his own. In 1754, the year of the town's incorporation, Ephraim Hartwell was elected one of the new town's first selectmen and served for many years. At different times, he was a surveyor, an assessor, and the sealer of leather. Hartwell was first granted a tavern license for the Ephraim Hartwell Tavern (shown here) in 1756. Hartwell was keeping the tavern in 1775, when the British marched down Battle Road. His son John would inherit the property and would remain innkeeper of this site on the North County Road. The ell on the left was built for Ephraim Hartwell and his wife, Elisabeth, as son John's family grew. (Courtesy of the Lincoln Public Library.)

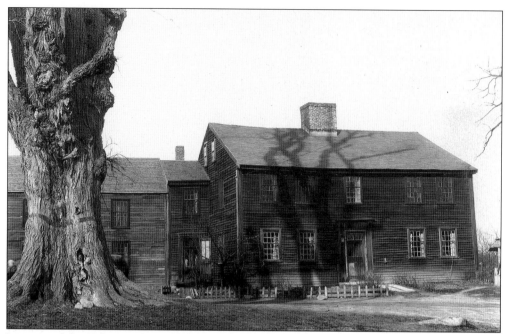

Just east of the Ephraim Hartwell Tavern on the North County Road in Minuteman National Park is the Samuel Hartwell House. Ephraim's first son, Samuel, married Mary Flint in 1769, and Ephraim gave Samuel the house next door that had been his grandfather's. Samuel and Mary had three daughters: Polly (b. 1770), Sally (b. 1773), and Lucy (b. 1774). (Photograph by Harriet Forbes, courtesy of the American Antiquarian Society.)

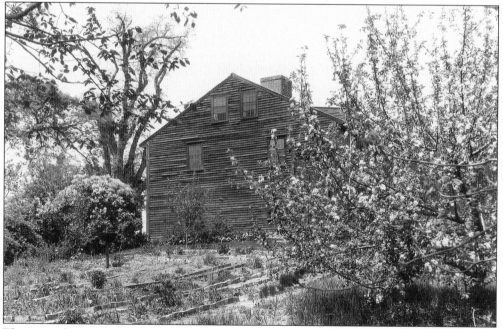

This is a side view of the Samuel Hartwell House. Today, only the foundation remains. Late one night in 1973, the building burned to the ground. (Photograph by Harriet Forbes, courtesy of the American Antiquarian Society.)

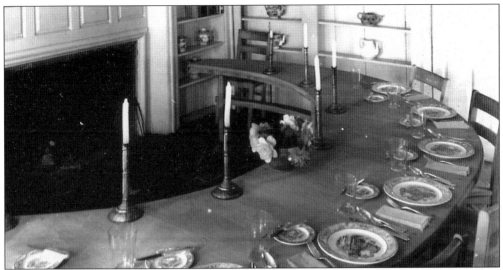

In 1926, the Samuel Hartwell House was purchased by Jane Fitch and Marion Poor. They transformed it into a restaurant, Hartwell Farm. This half-moon table was their design. It is pictured here set with the early antique period place settings they acquired and candlesticks fashioned from scrapers used originally in curing hams. The restaurant was a great favorite of Lincoln families young and old. The building was destroyed by fire in 1973. (Courtesy of the Society for the Preservation of New England Antiquities.)

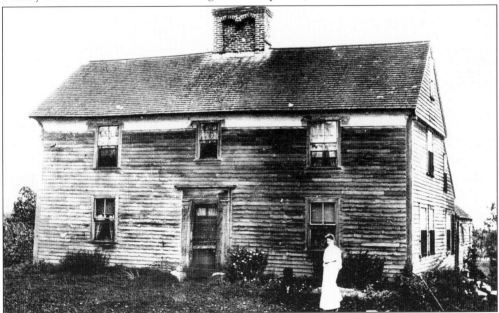

The Whittemore-Smith House, on Route 2A, is shown in 1900. The road between Concord and Lexington was much used by travelers, drovers, and teamsters carting tar, turpentine, and timber planks, but it lacked a house for "publick" refreshment. In 1725, a petition was presented by men from Concord, Groton, and Lexington to the county court for such a house. Whittemore's son Nathaniel, already a retailer of spirits, became the innkeeper of what was then the Bay Road Tavern. His business failed to prosper, and in 1756, he lost his license to Ephraim Hartwell. In 1775, the house was home to Capt. William Smith. (Courtesy of the Lincoln Public Library.)

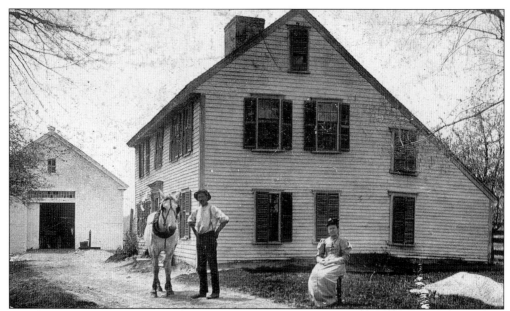

The Aaron Brooks house and farm were located down a lane across from the Whittemore-Smith House. Brooks bought land from Benjamin Whittemore, Elizabeth Dodge, Catherine Louisa Smith, and Thomas Brooks. This house appears to date from c. 1755, when he married Mary Stone. Their son Thomas later lived at the farm, until he sold it to the Beans in 1888. George and Abbie Bean are pictured here in front of the house. The house was sold to the Ricci family, market gardeners who came from Lexington. It stood vacant after their residency, and it was said that after the sills rotted out, the house settled on its foundation. It was later destroyed by fire. In 1963, the Riccis sold the land it had stood on to the Lincoln Land Conservation Trust. (Courtesy of the Lincoln Public Library.)

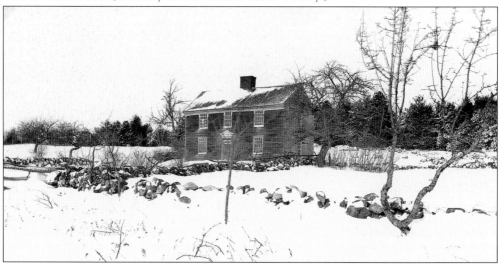

This picture shows the Josiah Nelson house, built c. 1750 by Josiah Nelson, who married Elizabeth Abrams in 1751. After a marriage of 24 years, they remained childless. After Elizabeth Nelson died, Nelson married Melisent Bond. They became the proud parents of seven children. Their descendants stayed in Lincoln. Badly deteriorated and used only for storage, the house burned down c. 1909. (Courtesy of the Lincoln Public Library.)

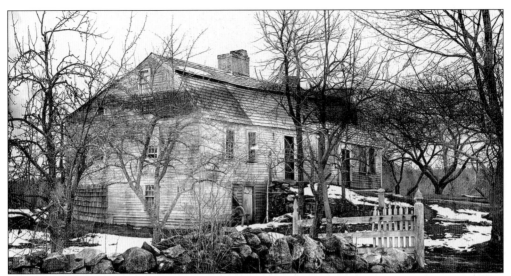

This early house, located on a site that was then part of Lexington (now part of Lincoln), is no longer extant. In 1723, Thomas Nelson bought 50 acres of land and the house and made a substantial addition. The Nelsons had two sons, Thomas and Josiah, and a daughter, Tabitha. By 1775, Thomas Nelson had died, and this house (with a later addition, as pictured) passed to Tabitha Nelson. (Courtesy of the Lincoln Public Library.)

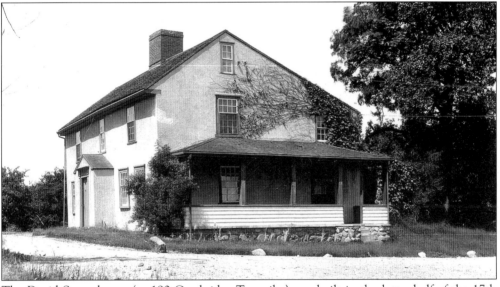

The David Stone house (at 190 Cambridge Turnpike) was built in the latter half of the 17th century. David Stone, the son of Gregory Stone and grandson of John Stone the elder, had been a trooper in King Phillip's War. David Stone built on land granted to his family for its contribution to Cambridge, land in Shawshine Corner, and land abutting the eight-mile line with Concord, called Cambridge Farms. Later, David Stone's house—with its 94 acres, originally within the boundaries of Lexington—was included within the boundaries of Lincoln. The house was owned successively by David, Daniel, Gregory, Gregory, and Gregory Stone. When Gregory Stone died in 1870, the house was sold out of the family. In 1911, it was owned by the Farrington family, who left it to the Congregational church as the Farrington Memorial. It was called Oak Hill Farm. (Photograph by Harriet Forbes, courtesy of the American Antiquarian Society.)

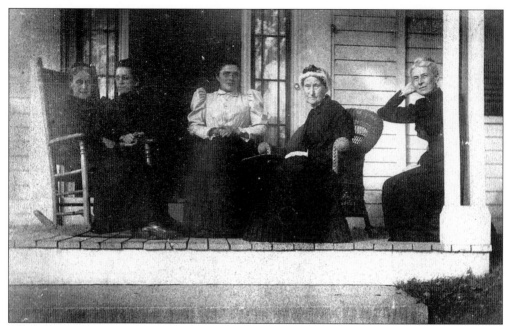

Pictured are members of the Abel Wheeler family on their porch at 161 Bedford Road. Charlotte Bemis, who married Abel Wheeler, is wearing the cap. Abel's cousin Stearns Wheeler built a cabin on the Wheelers' Flint's Pond wood lot and shared it with his Harvard College roommate, Henry David Thoreau. It has been said that Thoreau was told he could not build a cabin in Lincoln. In *Walden*, Thoreau referred to a Flint as a "skin-flint." Ephraim Flint was Abel's brother-in-law, having married Charlotte Wheeler's sister Susan Bemis. Abel Wheeler may have been the person who refused Thoreau's request to camp on the Flint's Pond lot. (Courtesy of the Lincoln Public Library.)

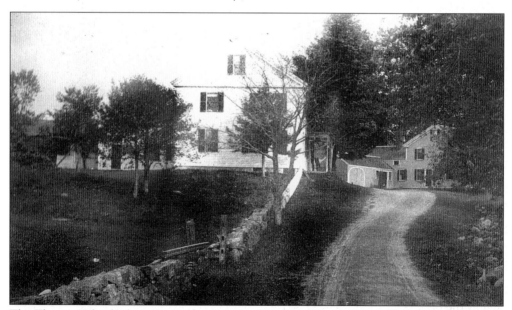

The Thomas Wheeler house was subsequently altered by Wheeler's son Abel. It would become the home of the Scriptures and their daughters. (Courtesy of the Lincoln Public Library.)

Hoar frost on the maple trees is seen here from the Baker Bridge. The road on the left was then known as Concord Road. Today, the farmhouse on the left is at 37 Old Concord Road. It is an old Billings house. William Burnham bought it from the Dodge family and added another 35 acres to his Baker farm, which he sold Adams. In 1911, Katherine Dodge wrote to C.F. Adams of her gratitude for the care that the new stewards had given to "the trees, most of all the dear old elm, which seemed to take a new lease of life the past summer." (Photograph by Herbert Gleason, courtesy of the Concord Free Public Library.)

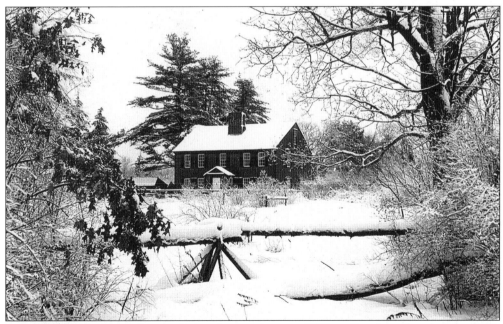

Pictured is the homestead at the Baker farm at the time William Burnham bought it in 1888. Built by the Billings family, it changed families through marriage. Jacob Baker, born in England in 1722, immigrated to Massachusetts. Here he met and married Grace Billings, who had been born in Concord in 1720. (Courtesy of the Lincoln Public Library.)

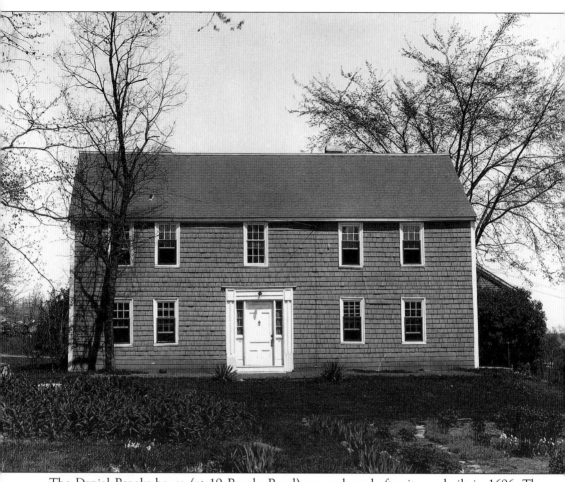

The Daniel Brooks house (at 19 Brooks Road) was enlarged after it was built in 1696. The house eventually became the home of Brooks's son Eleazer, one of Lincoln's most distinguished sons. He was appointed in 1773 to Lincoln's Committee of Correspondence and in 1774 as representative to the General Court. During the American Revolution, he achieved the highest rank of any Lincoln man to serve on the American side—brigadier general. His personal papers are held in the collections of the Lincoln Public Library. (Photograph by Harriet Forbes, courtesy of the American Antiquarian Society.)

Two
SMALL-TOWN HERITAGE

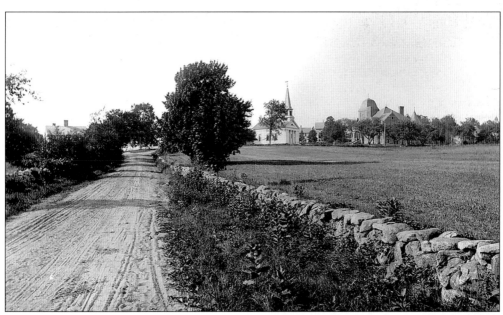

This is a view of the approach to the five-road crossing from Weston Road in 1877, when Rev. Henry J. Richardson wrote his essay describing the beauty of Lincoln. (Courtesy of the Lincoln Public Library.)

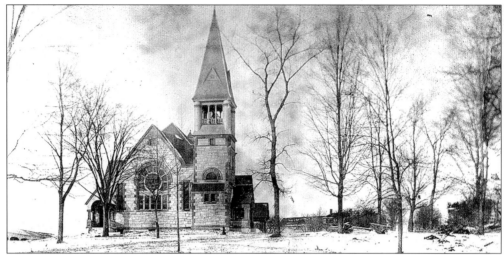

In 1891, construction of the third incarnation of the First Parish Church was begun. George Bemis had left $5,000 in his will to build a new church. Henry M. Francis of Fitchburg designed it in a Romanesque Revival style. As the building neared completion, a stranger passing through town was said to have asked, "How on earth can a town this size support two Episcopal churches?" When told it was Congregationalist, he replied, "I thought the people didn't look like Episcopalians." The new church, which is known as "the Stone Church," was dedicated on February 10, 1892. Two churches remained in town until 1936, when Lincoln families who had intertwined over the decades decided on a trial federation combining their two congregations, Unitarian and Congregationalist. In May 1942, a united church, the First Parish of Lincoln, was formed. The white Unitarian church was to be the sanctuary, and the Stone Church was to serve as a parish house. (Courtesy of the Lincoln Public Library.)

The Unitarian church was dedicated in November 1842. The building committee paid $20 for the plan and contracted Rueben Smith, who had built similar buildings in Stow. The building is Classic Revival in architectural style, with a recessed portico between the walls. Nineteen men endowed 31 pews to raise money for the construction. (Courtesy of the Lincoln Public Library.)

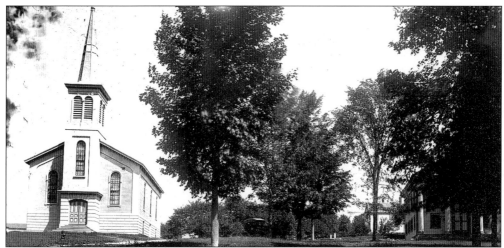

Pictured in a view facing south is the hill as Rev. Henry J. Richardson knew it—with the second building of the Congregational church and the first town hall. Before 1848, Lincoln had no building suitable for large gatherings. The building committee chose a Classic Revival Ionic temple to harmonize with the Unitarian church. The town approved and contracted Nathan S. Homer of Concord to construct the building. The town house would be used for town meetings, public functions, and a lyceum. A proposed high school was to be on the lower level. At the time, there were only six high schools in the county. Upon its staffing in 1852, the Lincoln High School made higher education available to all in this rural town. (Courtesy of the Lincoln Public Library.)

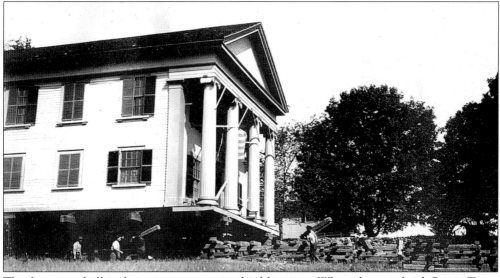

The first town hall is shown en route to its third location. When the new brick Bemis Town Hall was built in 1892, the wooden temple was moved across the street to the Chapin property, where it became Chapin's general store. After the death of James L. Chapin's son George in 1918, his widow planned to sell the store. Considering it essential to the town, Charles S. Smith bought it and moved it down the hill to land he owned. It was mounted on trestles and sledded down the hill. During the move, business continued. Customers mounted steps to reach two 12-foot planks railed on both sides to get mail and groceries as usual. (Courtesy of the DeNormandie family collection.)

Pictured on the common in 1911 is the R.D. Donaldson family. From left to right are the following: (front row) Malcolm Donaldson; R.D. Donaldson, holding Charlotte Donaldson; and Donald Donaldson; (back row) Robert Donaldson Jr. and Charlotte (Alcock) Donaldson, holding Gordon Donaldson. (Courtesy of the Donaldson family collection.)

The chestnut tree on the common is depicted on the official town seal. The tombs and the former Rice tavern, which became the home of the R.D. Donaldsons in the 20th century, are shown in the background. R.D. Donaldson was a contractor who built numerous houses in Lincoln, including Gordon Hall on Drumlin Farm. He and Charles S. Smith each served 25-year terms as town selectmen. (Courtesy of the Lincoln Public Library.)

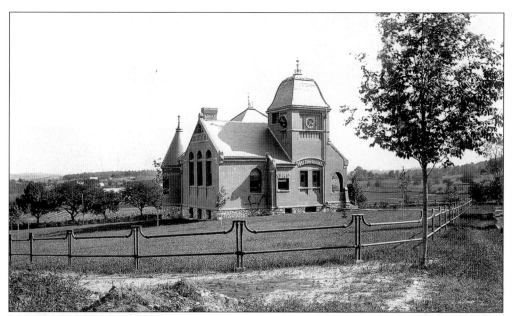

The Lincoln Public Library, given to the town by George Grosvenor Tarbell, is shown here. Tarbell chose Boston architect William Preston to build a finely detailed example of Queen Anne Revival architecture. Note the rural setting surrounding the library.

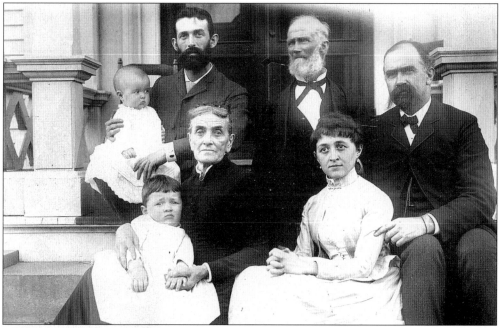

Members of the Tarbell family pose on their porch in 1887. From left to right are the following: (front row) baby Sarah Adams Tarbell, Martha E. Fiske Tarbell (Sarah's grandmother), Ida Adams Tarbell (the children's mother), and George Grosvenor Tarbell (Charles Lee Tarbell's son); (back row) baby George G. Tarbell (namesake of the library donor), Charles Francis Tarbell (George G. Tarbell's father), and Charles Lee Tarbell (brother of the library donor). (Courtesy of the Tarbell family collection.)

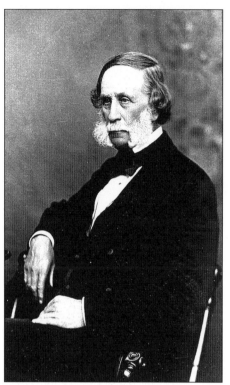

George Bemis (1809–1890), a successful businessman and bachelor, grew up in Lincoln on Mackintosh Lane. He tried out several careers, first in printing and then in real estate, before he finally began investing, particularly in copper, and made his fortune. Deservedly known as Lincoln's greatest benefactor, he gave 10 acres of land for the Lexington Road Cemetery, a $5,000 contribution to build the Stone Church, and Bemis Town Hall, with an endowment for a lecture series that continues to this day. (Courtesy of the Lincoln Public Library.)

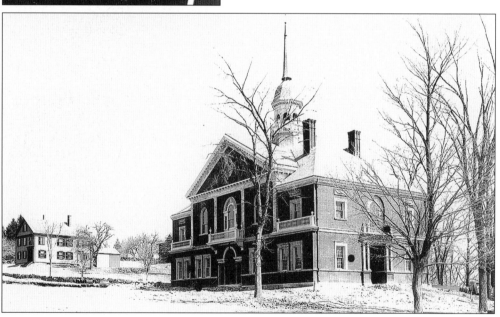

Bemis Town Hall, the gift of George Bemis, was dedicated on May 26, 1892. The building committee held a competition and chose H. Langford Warren, chief assistant to H.H. Richardson, the architect of the Trinity Church in Boston. For the town hall, Warren drew upon the work of Andrea Palladio, as reflected in the Palladian window above the main entrance. A second entrance on the south slope was intended for everyday use by town officials. (Courtesy of the Lincoln Public Library.)

John Pierce (1830–1910) was a successful Lincoln businessman who became a town benefactor. Pierce married Mary Elizabeth Wheeler, with whom he had a son, Robert, and a daughter, Elsie. (Courtesy of the Flint family collection.)

The Pierce House, located on Weston Road, is pictured here. In 1900, John H. Pierce, then a widower, built this stunning Georgian colonial for his unmarried daughter, Elsie. Moved by the the tragic Baker Bridge train wreck of 1905, when Lincoln homes were used to house recovering victims, Pierce bequeathed the house to the town as a hospital and park but stipulated life tenancy for his daughter Elsie. She in turn bequeathed the income from a $25,000 investment to the town, provided that her brother and his wife, Grace, who lived with her, were granted life tenancy. Upon Grace's death in 1964, the house and its 32 acres became the property of the town. Although it was never used as a hospital, it is the center of social functions both public and private. Summer concerts and weddings are held on the grounds. (Courtesy of the Lincoln Public Library.)

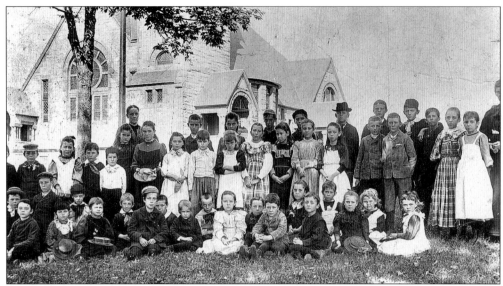

This 1894 photograph of Lincoln schoolchildren was taken in front of the Stone Church. From left to right are the following: (first row) Herman Wheeler, Alice Riley, Monica Lennon, Lossie, Laird, Daniel Lennon, Catherine Dempsey, Wallace Dutcher, George Tarbell, Lizzie Dutcher, and Gertrude Dempsey; (second row) unidentified, Austin Ham, John Lahey, unidentified, Horace Ham, unidentified, Marjorie Hartwell, Mary Lennon, and Mary Dempsey; (third row) Joseph Craven, unidentified, Sarah Tarbell, unidentified, Alice Flynn, Ellen Riley, Georgia Sherman, Alice Jones, Elizabeth Wheeler, Bertha Graves, Mary Dempsey, Arthur Browning, unidentified, Abigail Hartwell, and Nora Lennon; (fourth row) Annie Craven, unidentified, unidentified, Helen Flynn, Frank Flynn, Richard Flynn, George Browning, Alonzo Calkins, William Riley, and James Lennon. The teacher on the left is Carrie B. Chapoin, and partially visible on the right is teacher Harriet Sawin. (Courtesy of the Lincoln Public Library.)

A landscape view of the village center shows the Centre School (left), the second building of the Congregational church, and the first town hall. (Courtesy of the Lincoln Public Library.)

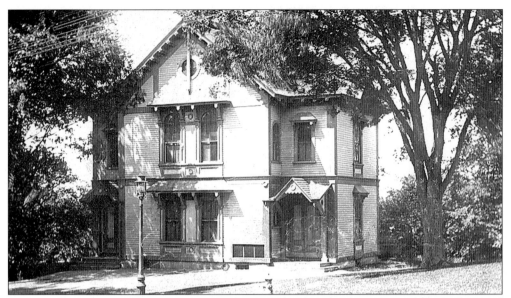

Built in 1870, Centre School was a district school. Under the school were housed the fire hose and the town hearse. In case of fire, the church bell was rung. Classes were disturbed whenever the Chapin's horse Bessie had to be hitched to the fire hose. During lunch hour in cold weather, the boys would climb into the hearse to eat their lunches. (Courtesy of the Flint family collection.)

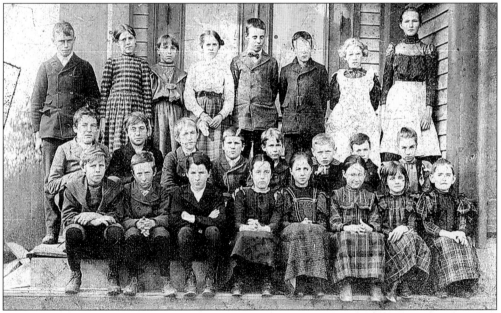

Lincoln schoolchildren gather in front of the Centre School c. 1900. From left to right are the following: (front row) George Newton, Joseph Whipple, Martin Craven, Grace Printon, Emma Cunnert, Lily Bond, Helena Lennon, and May Dougherty; (middle row) Roderick Laird, Elmer Bean, John Lahey, Robert Dutcher, Daniel Lennon, Andrew Dougherty, Sumner Smith, and Anna Wheeler; (back row) Henry Neville, Elizabeth Dutcher, Katie Dempsey, Ruth Fickett, Austin Ham, William Costello, Mary Dempsey, and Lena Wilson. (Courtesy of the Costello family collection.)

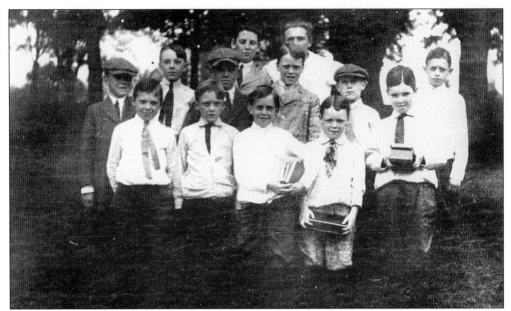

Schoolboys are shown in 1915. From left to right are the following: (front row) G. Flint, Sidney, R. Robus, G. Donaldson, and D. Donaldson; (middle row) E. Rocks, ? Roth, H. Rocks, M. Donaldson, W. Doten, and E. Flint; (back row) R. Donaldson and J. Eaton. (Courtesy of the Donaldson family collection.)

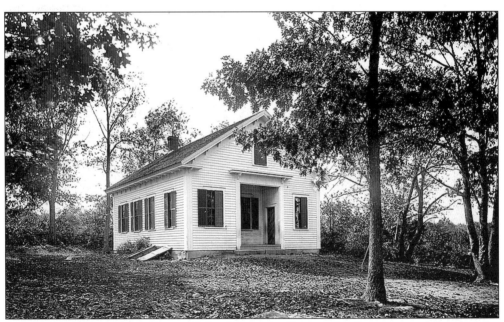

Pictured here is the North District School. Lincoln district schools were consolidated to the south and center of town. In 1908, students from the northern and the eastern part of town joined those at the Centre School. North School stood on North Great Road, at what is now Bedford Lane corner. (Courtesy of the Lincoln Public Library.)

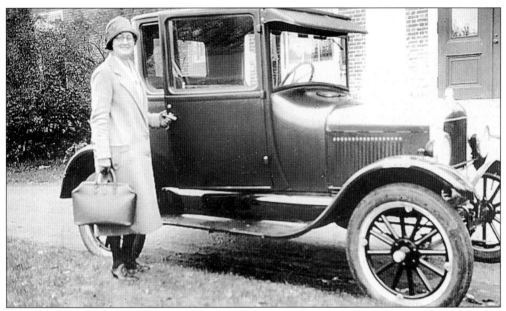

Dorothy Rudolph Snelling, town nurse, is pictured with the first town car. In 1926, the American Red Cross offered to turn the old car over to the town and contribute $100 if the town would release them from further responsibility. The proposition was accepted by the selectmen, and a new Ford coupe was purchased from Wayland Motors. (Courtesy of the Snelling family collection.)

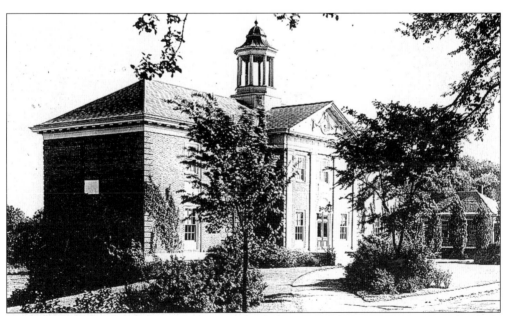

When the state police condemned Centre School, the town did not try to renovate it but built a new school instead. J. Harleston Parker was chosen as the architect, and R.D. Donaldson was the contractor. The building is a fine example of the Colonial Revival style. The basement rooms were almost wholly above ground level, with easy access to the playground. The copper cupola was the gift of Charles Smith. (Courtesy of the Lincoln Public Library.)

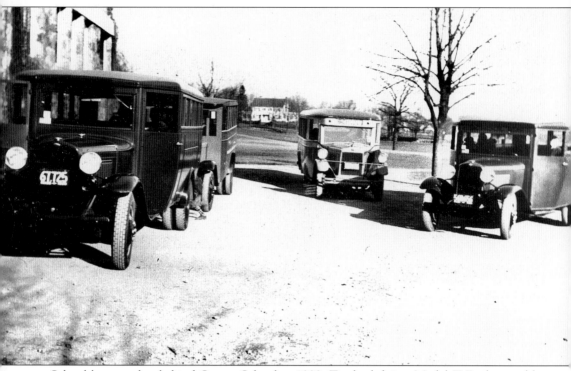

School buses gather behind Center School *c.* 1932. To the left is a Model T Ford owned by Thomas Dee, and behind it is another vehicle, owned by Matthew Doherty. Doherty also owned the Garfield vehicle shown in the center and the Model B Ford on the right. (Courtesy of the Doherty family collection.)

Lincoln's first telephone office was built c. 1902 by William Robus at 23 Sandy Pond Road. Robus was a Concord telephone lineman who was taken to Concord each work day by his wife in their horse and buggy. He carried his tools and wires in a leather bag over his shoulder, installing and repairing lines as he walked each day from Concord to Lincoln. During World War I, Robus served in the army, and the building was left vacant. Later, the building was moved to the woods off Conant Road and was occupied by the hermitlike Elmer Rollins, whose sons ran the Rollins Brothers store. It was later moved to New Hampshire. (Courtesy of the Algeo family collection.)

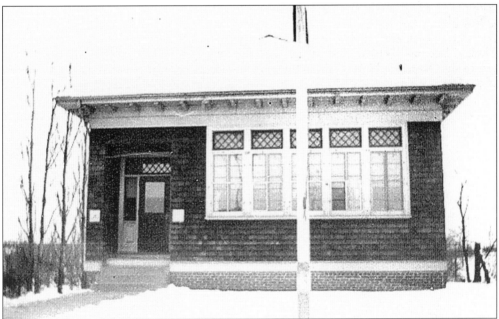

Lincoln's second telephone office is shown here. William Robus returned from serving in World War I in 1918 and opened a new office adjacent to Center School. The first of many operators were Mae Dougherty, Jessie Hunter, and Emily Robus. In 1954, a new system was installed, and the operators were honored with this accolade: "The operators . . . have given much good service to our fire and police. . . . On fire calls they notify fire engineers, truck drivers and fireman, answer inquiries as to location and nature of fires. . . . All this at no cost to the town. On police calls they locate the officer on duty. . . . All this will stop on April 30, 1955 when the dial system goes into effect." (Courtesy of the Algeo family collection.)

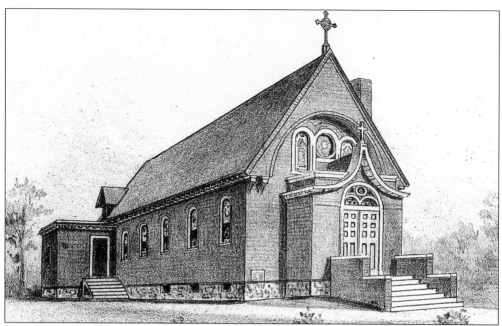

St. Joseph's Catholic Church was built in 1904. Catholic families previously worshiped in surrounding towns. Land for the church was donated by Helen Welch of Concord, and others volunteered money and services. (Courtesy of St. Joseph's Church collection.)

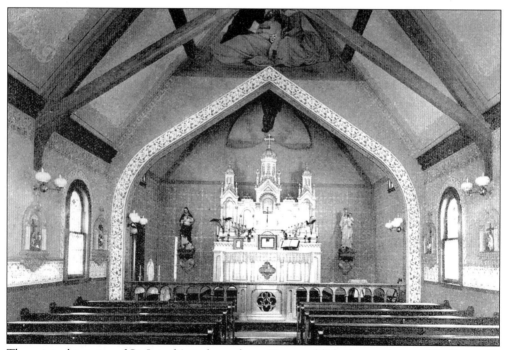

The original interior of St. Joseph's is shown here. First established as a mission of St. Bernard's in Concord, the congregation continued to grow and was officially made a parish with a resident priest on November 21, 1945, by Richard J. Cushing, archbishop of Boston. (Courtesy of St. Joseph's Church collection.)

Across the railroad tracks from St. Joseph's Church on Lewis Street was the W.K. Lewis pickle factory. It produced pickles from the 1870s to 1910, until a blight struck cucumbers and the business ceased. Selectmen Donaldson and Smith thought it could be used as the town barn and bought it *c.* 1921. Their plan did not bear fruit. Charles Foreman and Billy Harding repaired and divided it. For the past 30 years, it has been the factory for Allen Bicycle Racks. (Courtesy of Ruth Williams.)

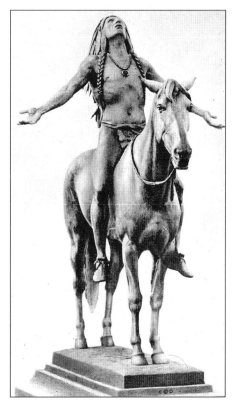

The rider and horse used by Cyrus Dallin for the statue *Appeal to the Great Spirit* were from Lincoln. The statue stands at the entrance to the Museum of Fine Arts in Boston. Charles Foreman, a Cherokee Indian, worked as a stable hand for John Quincy Adams, and the horse (named Major) was one of the many in the stable. Behind the Foreman property south of Route 117, there was a sulky practice track where the Adams horses were trained. (Courtesy of the Dallin Museum.)

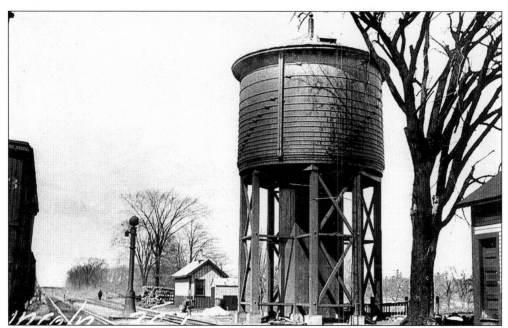

This water tower supplied water for railroad engines and livestock cargo. Henrietta Warner of nearby Mackintosh remembered hearing the sounds of cows and sheep from her bedroom window late at night when the train stopped. (Courtesy of the Lincoln Public Library.)

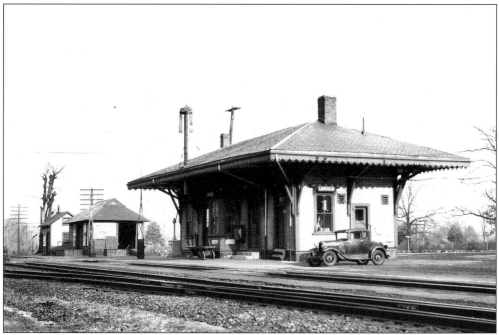

Tons of freight passed through Lincoln heading east from the Midwest and West to New England manufacturers. Lincoln Station, shown here in 1930, was the highest point on the line between Cambridge and Fitchburg. On a clear night, you could hear the train struggle to climb over the spot and then get faster and faster as it reached the downgrade, clicking off to its destination. (Courtesy of the Lincoln Public Library.)

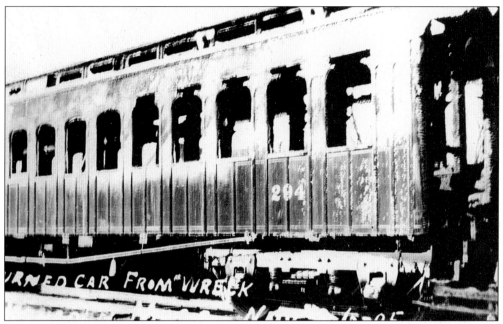

A burned-out car from the train wreck on the Sunday before Thanksgiving, November, 26, 1905, suggests the magnitude of the tragedy. (Courtesy of the Lincoln Public Library.)

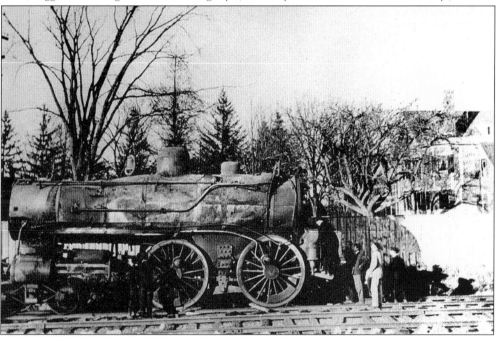

Nine people lost their lives and scores where injured at the Baker Bridge crossing when the Maynard local train was telescoped by the Montreal Express. Dr. Blodgett and Mrs. Blodgett and their boarder Hattie Heath heard the crash during supper and rushed to the scene. They walked directly down into the wreck, extricating bodies, aiding the injured, and comforting passengers searching for loved ones. The injured were carried to Lincoln homes, where many remained while convalescing. (Courtesy of the Lincoln Public Library.)

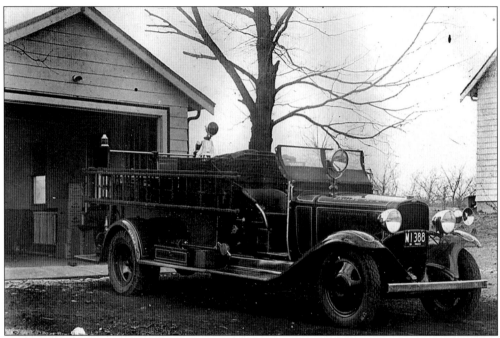

The North Lincoln fire truck is shown in August 1938. It was kept at Tracey's garage on the Cambridge Turnpike at the Bedford Road intersection. (Courtesy of the Bowles family collection.)

A fire truck was kept on North Great Road at Algeo's in 1934. John Algeo is shown at the wheel, with John Algeo Jr. and Leo Algeo behind him. Alice Algeo holds the shovel, and Julia White is standing next to her. (Courtesy of the Butcher family collection.)

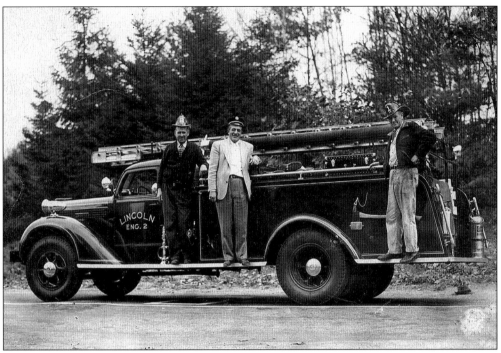

A 1947 Lincoln Diamond T fire engine is manned by Frank Gordon Sr., Ed Mascari, and Joseph Tracey. (Courtesy of the Bowles family collection.)

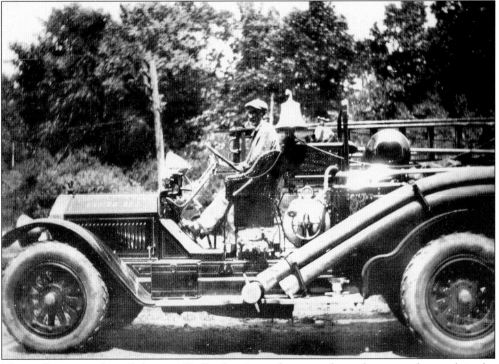

Martin Corrigan, whose father was DeCordova's coachman, is shown here on a fire truck in the early 1900s. (Courtesy of the Lincoln Public Library.)

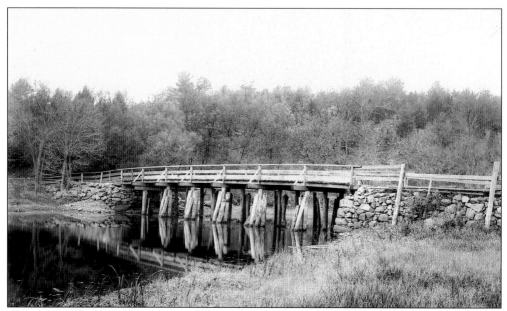

This is how Lee's Bridge and causeway appeared in 1901. The state planned to replace this bridge, which was in the line of sight of C.F. Adams's home. Adams was not pleased with the state's design and asked his friend Ogden Codman to design a more suitable bridge. Adams then took the proposal before the state, offering to pay the additional cost of the Codman-designed bridge. (Photograph by Herbert Gleason, courtesy of the Concord Free Public Library.)

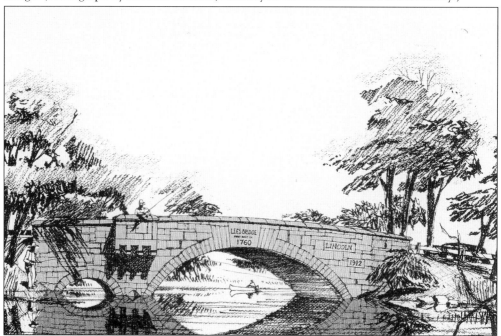

The state agreed to C.F. Adams's proposal for a new bridge, and in 1912, the completed span was designated the Mr. and Mrs. Charles Francis Adams Memorial Bridge. The bridge remained until it collapsed in October 1999 under the excess weight of a truck. It is currently under restoration. (Rendering by H. Morse Payne.)

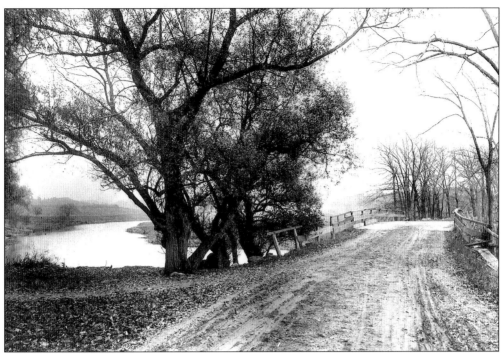

Lee's Bridge is pictured in 1901. (Photograph by Herbert Gleason, courtesy of the Concord Free Public Library.)

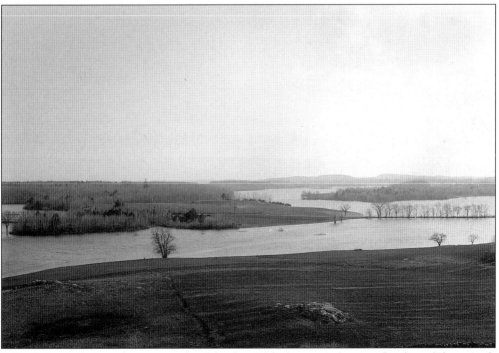

This photograph shows a water-covered landscape during annual spring flooding. (Photograph by Herbert Gleason, courtesy of the Concord Free Public Library.)

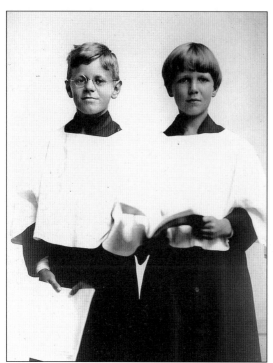

Ehlert and Albert Seeckts were altar boys at St. Anne's-in-the-Fields Episcopal Church c. 1912. (Courtesy of the Seeckts family collection.)

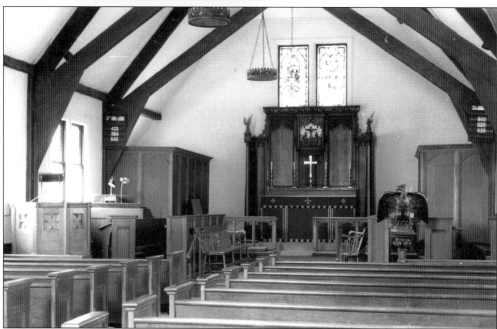

Pictured is the interior of St. Anne's-in-the-Fields Episcopal Church, on Concord Road. In 1879, Howard Snelling gave land to build an Episcopal church. At the time, the closest one was in Waltham. Snelling also assumed the responsibility of raising funds for and supervising work on the construction. The church was completed in September 1873. Additional land was given in 1929 by Lorenzo Brown, and a later gift from the DeNormandie family enabled expansion of the parking lot area. (Courtesy of the St. Anne's Church collection.)

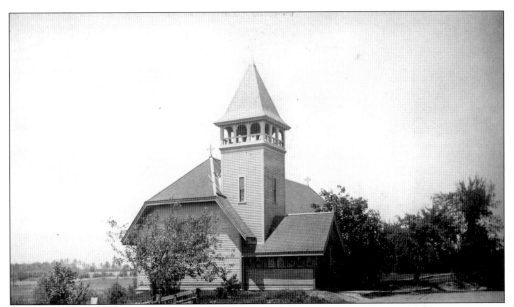

The exterior of St. Anne's-in-the-Field Episcopal Church is pictured c. 1912. (Courtesy of the St. Anne's Church collection.)

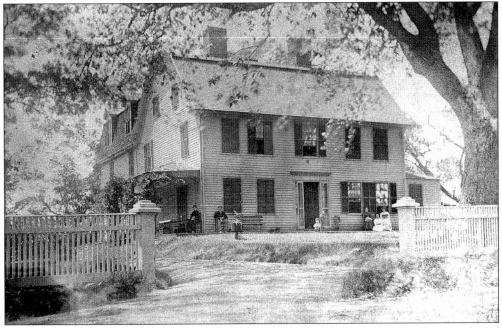

This is how the Concord Road home of Howard Snelling looked in 1884. Snelling purchased the house from Edward Sherman Hoar, a friend of Henry David Thoreau. Hoar had Thoreau survey his property, which included Mount Misery. The house burned in 1928. Shown, from left to right, are Anna Snelling, sons Rodman and Howard Snelling, Bessie Storrow, Caroline Snelling, and Emma Snelling. (Courtesy of the Lincoln Public Library.)

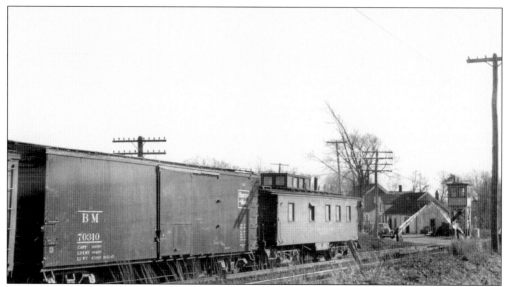

Rooney's Crossing, on South Great Road, was formerly Kelly's Crossing. The two railroad crossings in Lincoln were at South Great Road and Old Sudbury Road. Each had its own attendant who would come out when he heard the signal, a bell in the shed. He would then manually crank the gates up and then down again when the train had passed. Often, an overloaded freight car, its engine overworked, would come to a halt and block the crossing. A fresh engine would then have to be sent out from Concord. Later, an underground cable was installed, which allowed one attendant to operate both gates. A tower was also built for the gatekeeper to climb in order to get a clear view of the tracks at both crossings. (Courtesy of the Lincoln Public Library.)

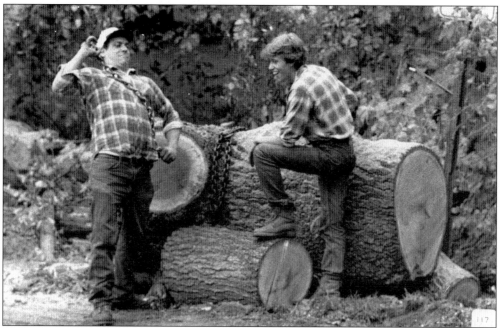

College students Gary White, tree climber, and James Pianka worked hard for the highway department during the summer. (Courtesy of Norman Hapgood.)

Three
RURAL CHARACTER

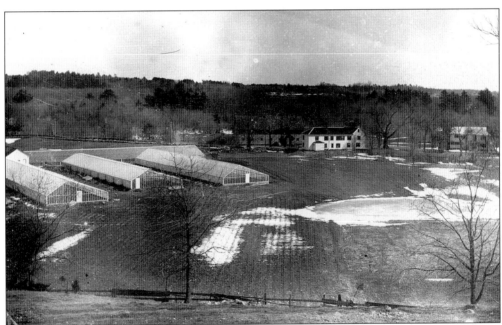

The three Flint greenhouses are shown here. In 1875, there were 94 farms in Lincoln. On these farms, there were in total 233 buildings, 86 houses, 87 barns, 35 sheds, 11 carriage houses, 2 corn cribs, 1 icehouse, 2 cider mills, and 9 outbuildings. Land use was tabulated as 2,542 acres in crops, 3,314 acres in woodland, 2,229 acres unimproved, and 1,241 acres unimprovable. Market gardens occupied 24 acres, and 171 held orchards, most of them cultivating apples. (Courtesy of the Flint family collection.)

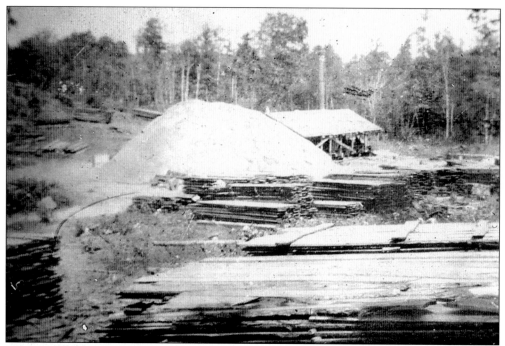

Chestnut trees were used for milling boards in the 19th century. By the early 20th century, blight had destroyed almost all of Lincoln's chestnut trees. Because the wood was particularly weather resistant, it was milled into boards to repair barns and outbuildings. (Courtesy of the Flint family collection.)

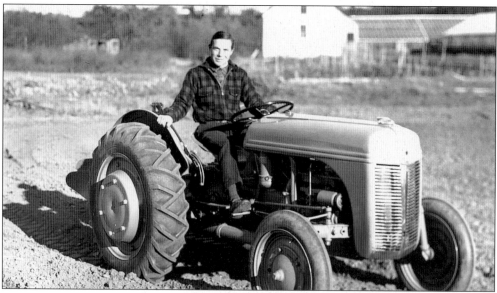

Henry Flint is shown here on his tractor in the 1950s. He was the winner in a plowing contest held at Warehouse Point, Connecticut. The prize was a brand-new Ford tractor, nicknamed "Sophia" after the goddess of wisdom. (Courtesy of the Flint family collection.)

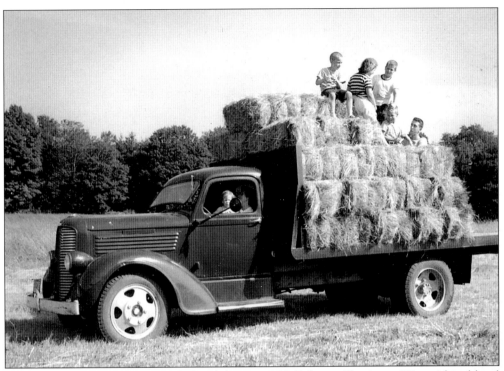

The Flint truck was regularly loaded with hay in 1956. Ephraim Flint's son Warren hired local youths such as Perry Culver Jr. and Tim Cole, pictured here, for haying and other dairy work. The ninth generation of Flints still farm the Flint grant. (Courtesy of the Flint family collection.)

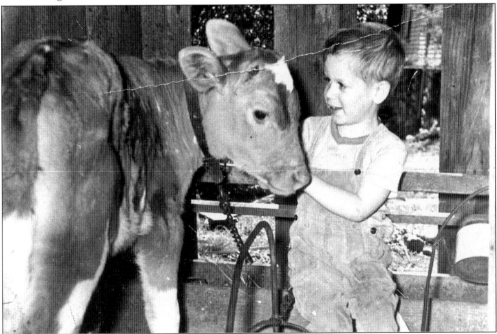

A young farmer, Warren Flint, cajoles one of the family's many calves. (Courtesy of the Flint family collection.)

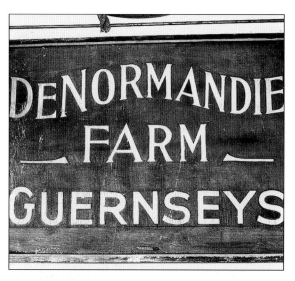

This sign once adorned the Denormandie dairy barn. Other Lincoln dairies included Higginson, Glendale, Woodridge, Stone, Verrill, Whitcomb, Danoski, Kimball, Haines, Lunch, and Fernald. Piggeries were kept by the Boyce, Brooks, Butcher, Coburn, Connors, Cotoni, Domenichella, Davis, Dean, Hanlon, MacHugh, Shea, Silva, Wilson, and Pimental families. The odors from these farming operations gave Lincoln a decided fragrance. As the train approached Lincoln, the conductor is reputed to have said, "Manchester-by-the-Sea, Lowell-by-the-River, and Lincoln-by-the-Smell." (Courtesy of the DeNormandie family collection.)

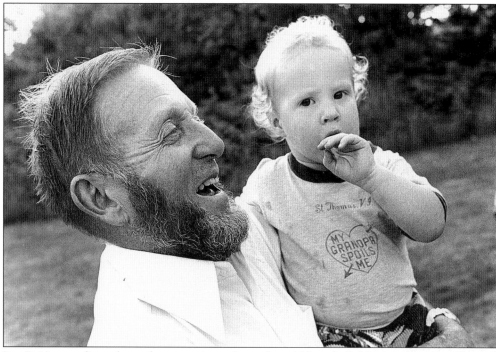

Jim DeNormandie and grandson are pictured together. Although DeNormandie was a Harvard graduate, his real love was dairy farming. He raised a herd of 130 while active in the state division of livestock disease control, the Massachusetts Selective Breeding Association, and the Massachusetts Guernsey Association. He formed a partnership with Floyd Verrill of Concord to establish the first frozen-food plant in the area, and the dairy became known for selling the best ice cream in the area. After suffering a devastating loss by fire of his barn and herd, DeNormandie ran for state representative. He served from 1955 until 1964 and went on to serve as a state senator from 1965 to 1972. His proudest political accomplishments include helping to ensure the preservation of Walden Pond, Minuteman National Park, and the Cape Cod National Seashore. He died in 1987 at the age of 80. (Courtesy of the Ted Palumbaum collection.)

Small buildings were often moved by hired help. After a number of even logs, three feet long and six inches in diameter, were placed under a building, a team could pull it forward. As the rolling logs in the rear were uncovered, they would be taken to the front of the building to help roll the structure forward. (Courtesy of the DeNormandie family collection.)

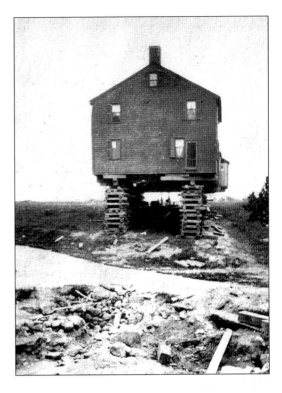

A glass milk bottle from the DeNormandie Dairy Farm conjures up the rural agricultural past. (Courtesy of the DeNormandie family collection.)

55

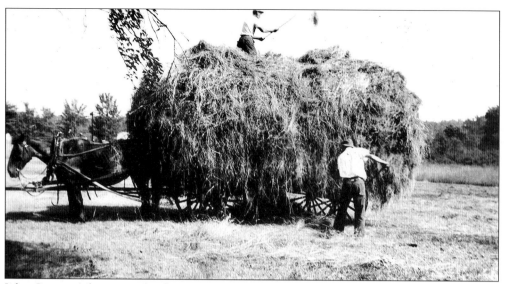

John Quincy Adams went by the name of Quincy. Shown haying with Dan Ryan, Adams was the son of John and Marion Adams. (Courtesy of the Adams family collection.)

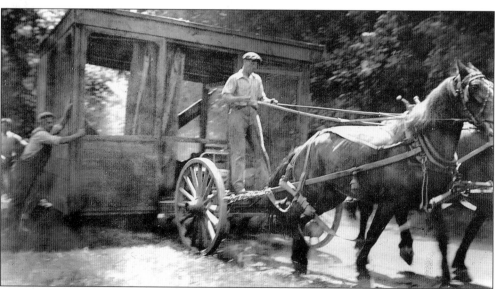

In June 1932, Dan Ryan, Willie, and John moved the piazza from the Hall house to the barn. (Courtesy of the Adams family collection.)

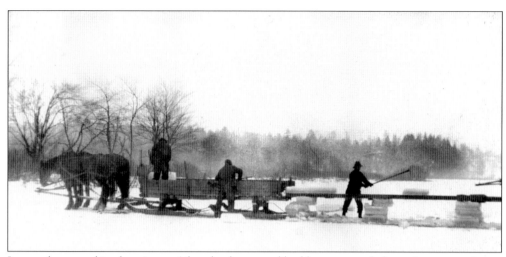

Ice was harvested in the winter. After the farm pond had been scraped clear of any snow, it was scored with lines two feet apart, using a horse-drawn marker. The process was then repeated at right angles to mark off squares. An ice saw was used to cut the blocks. (Courtesy of the Adams family collection.)

Ice blocks were pushed with a pick pole into the channel leading to a conveyor. Grappling hooks were placed behind them, and the horse would haul them up as far as the icehouse door. Another conveyor would push the cake inside. Two men with "cant dogs" would lift the cake into place. When a layer was complete, it was covered with sawdust. When full, an icehouse 15 by 15 feet square could hold 50 layers of ice. (Courtesy of the Adams family collection.)

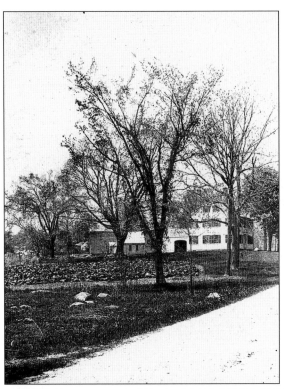

The Brooks family home, on Cambridge Turnpike (Route 2), was built in the early 19th century by a descendant of the 18th-century Brooks family, the founding fathers of Lincoln. (Courtesy of the Lincoln Public Library.)

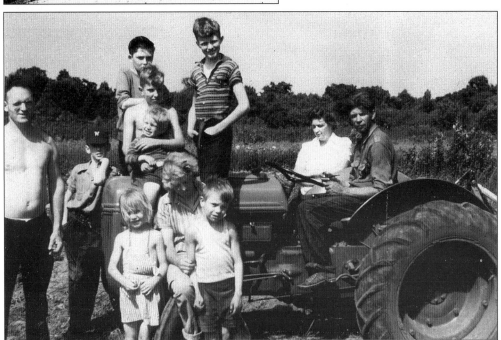

Brooks family members and friends gather on the Ford Ferguson tractor in the early 1940s. Bud Cress, Charlie ?, and Buddy Cress are on the hood. Standing are, from left to right, Leu Cress, Jimmy Beardsley, Carol ?, mother Maud Brooks, and an unidentified boy. Behind the wheel are Albert and Aunt Hazel. (Courtesy of the Brooks family collection.)

Located on Tower Road, the home of Charles Lunt and his wife was built *c.* 1865 by James Kelley. Greenhouses and a roadside stand were located below the house, near where the town well was built by the town in 1965. (Courtesy of Julie Campobasso Walton.)

The Ryan House was built in the 1800s by John and Anastasia Ryan. The Ryans were very active in St. Joseph's Catholic Church. John Ryan helped to build the stone foundation for the church. The Ryan land was sold in the 1990s and is now the site of the Ryan Estates on Lincoln Road. (Courtesy of the Margaret Chisholm collection.)

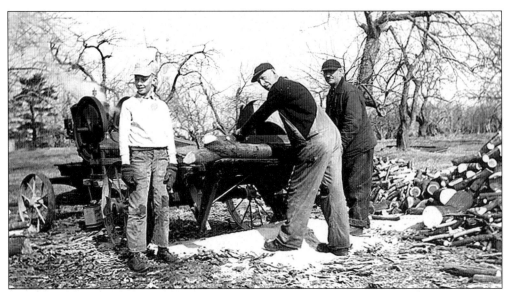

Ronnie McIvor (left), Ralph Butcher (center), and Elmer Bean operate an early power saw called a one-lunger, a one-cylinder John Deere tractor engine attached to a belt that powered the saw. (Courtesy of the Butcher family collection.)

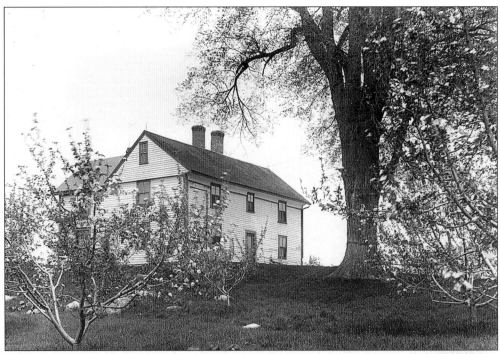

This is a view of the Captain Smith House. Louisa Smith deeded 100 acres to the Butcher family. The house was restored and is now part of Minuteman National Park. (Courtesy of the Lincoln Public Library.)

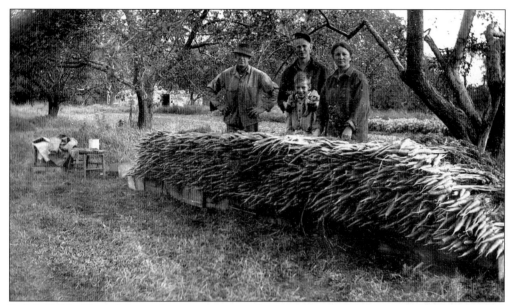

Ralph (left), Al, and Annie Butcher, along with young Ronnie McIvor, stand proudly behind a neatly stacked row of freshly picked carrots ready to be taken to market. (Courtesy of Doris and Robert Hanson.)

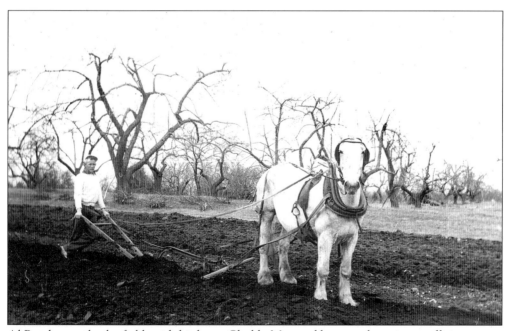

Al Butcher works the fields with his horse Chubb. Man and horse make quite an efficient team. (Courtesy of the Butcher family collection.)

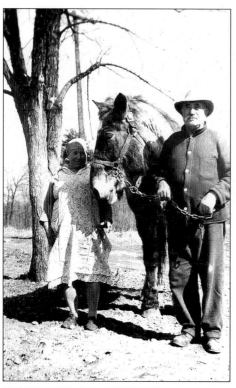

Catherine and Nicholas Cotoni pose with their horse Dolly. The Cotonis arrived in Lincoln from Italy in 1901 and bought 12 acres on Mill Street. Nicholas Cotoni and his four brothers tended the horses, milked the cows, and kept their mother supplied with wood and water. All 12 acres were planted with vegetables, and every summer evening, Joe Cotoni and his brother Angelo drove the full truck to the Boston market. (Courtesy of the Cotoni family collection.)

The Nicholas Cotoni family bought their farmland in 1901. They also raised Yorkshire pigs and sometimes had as many as 500 at a time. To feed his pigs, Joe Cotoni drove around town early in the morning collecting Lincoln garbage, returning by 7:00 a.m. in time to drive the school bus. The rest of his day was spent with farm work. He finally retired and sold his land but remained in Lincoln and continued to drive the school bus. His sons, Joe Jr. and Arthur, remained in Lincoln. Arthur became a fireman, and Joe Jr. is an automobile mechanic and owner of Joey's Auto Repair. (Courtesy of the Cotoni family collection.)

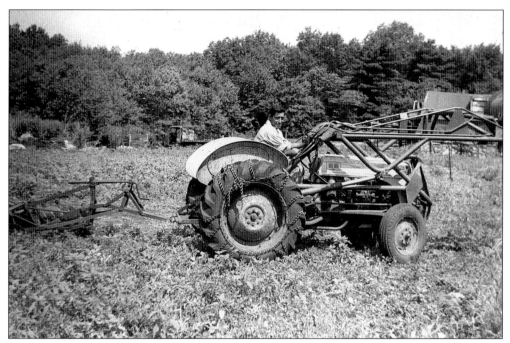

Joe Cotoni is shown as a young farmer preparing one of his fields. (Cotoni family collection.)

The Cotoni family used many fields to produce vegetables sold at the Boston market. This field shows a crop of fresh scallions ready for harvest. (Courtesy of the Cotoni family collection.)

From left to right, Manny Silva, Harry Cook, Jack Algeo, Ken Gerrish, Myrtle Hanlon, and Alice Algeo stand on the back of the town fire truck in the spring of 1930. (Courtesy of the Cook family collection.)

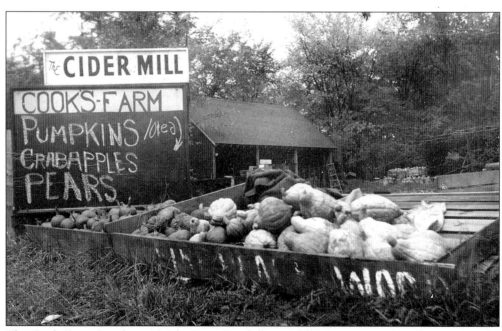

The Cook Farm Stand, on North Great Road, has its fall harvest in and ready for sale. The pumpkins are only 10¢ apiece. (Courtesy of the Cook family collection.)

Harry Cook and Leo Algeo pose for a picture before a playoff game. (Courtesy of the Algeo family collection.)

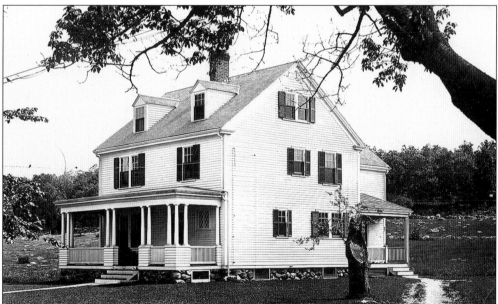

Tom Dee built this house on Virginia Road in North Lincoln in the summer of 1915. His parents, John and Alice Dee, lived across the road. They had purchased the 80-acre Hartwell Farm in 1875. Four Dee children and granddaughter Margaret Algeo were born in the Hartwell House. Tom sold the home to his sister Mary and her husband, John Algeo, in 1932. Leo Algeo was born here in 1922. Margaret Algeo sold the house and land to the National Park Commission in 1965. (Courtesy of the Algeo family collection.)

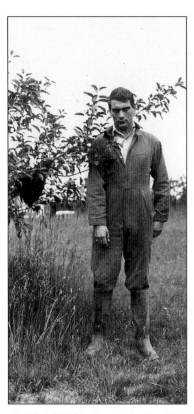

Hans van Leer, a key figure in Lincoln's land-conservation movement, tends to his bees c. 1936. Van Leer was a Lincoln farmer and advisor to the Middlesex Soil Conservation District. (Courtesy of the van Leer family collection.)

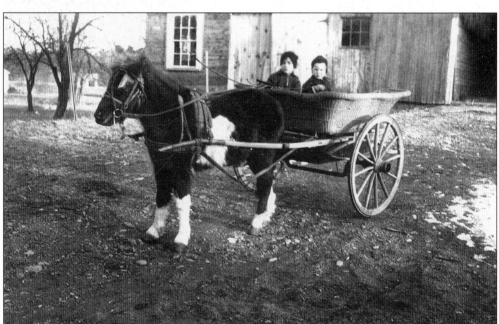

The van Leer children are shown here in a tip cart drawn by a pony. Van Leer owned 100 acres on Old Sudbury Road and 60 acres on Baker Bridge Road. (Courtesy of the van Leer family collection.)

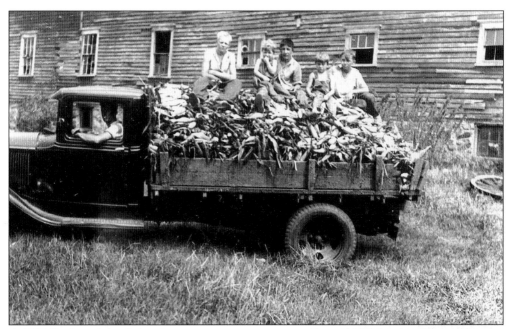

A 1932 Ford truck loaded with sweet corn is on its way to Faneuil Hall Marketplace, in Boston. The driver is Les Sherman. Hans and Karl van Leer and three hired boys from Waltham ride on top of the corn. (Courtesy of the van Leer family collection.)

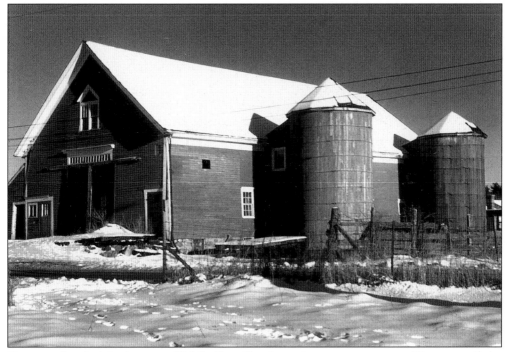

Hans van Leer's dairy barn, on Old Sudbury Road, was home to an average 60 cows until the mid-1950s. (Courtesy of the van Leer family collection.)

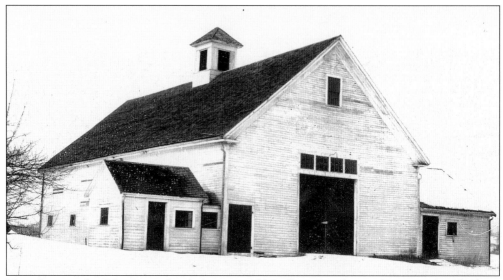

This photograph of the Boyce family barn on Old Sudbury Road was taken in 1956. The barn housed livestock, crops, and produce for marketing in Boston. In the 1800s, Manley Boyce would leave Lincoln with his horse and wagon at 2:00 p.m. for Boston. Arriving in the early evening, he would stable his horse near the Callahan Tunnel and would be ready for the market to open at 3:00 the next morning. By 8:00 that same morning, he would have hitched his horse and loaded the empty boxes and would be headed back to Lincoln. (Courtesy of the Boyce family collection.)

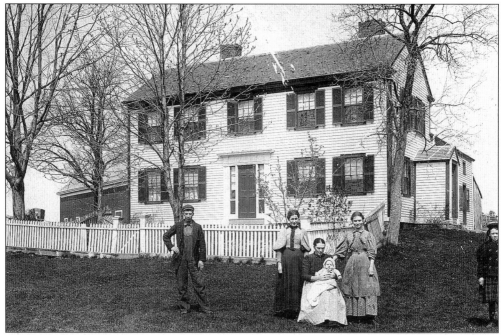

This is a view of the Boyce family homestead. From left to right are Michael Boyce, Mary Boyce, Mrs. Boyce (holding Edward Boyce), Josie Coughland, and Elizabeth Boyce. The Boyce family came to Lincoln in the 1870s and acquired property here. (Courtesy of the Boyce family collection.)

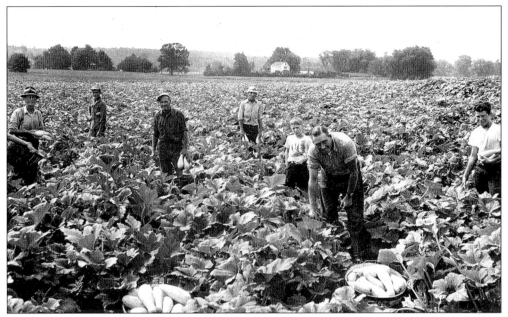

Dan and James Boyce, with Ray Bowles and hired helpers, pick summer squash in the 1950s. (Courtesy of the Boyce family collection.)

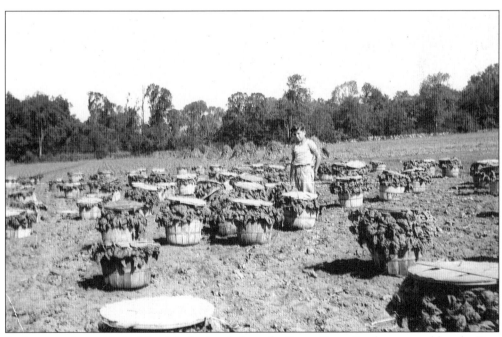

Baskets overflow with freshly picked spinach from the Boyce Farm. Produce was sold to the First National grocery stores and at the Cambridge open-air market. (Courtesy of the Boyce family collection.)

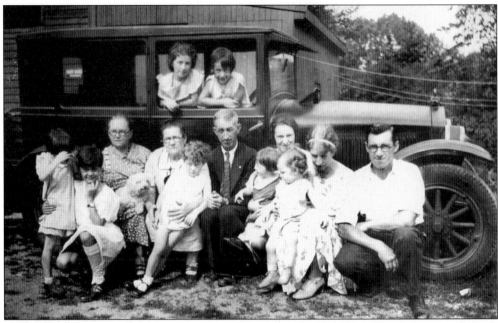

Here is a kinfolk gathering. John H. Coane and his wife, Amolie Panther Coane, pose with their family on the running board of the family car. Also pictured are John A. Coane, about four years old, and grandmother Marie Lopez, visiting from Oklahoma. (Courtesy of the Coane family collection.)

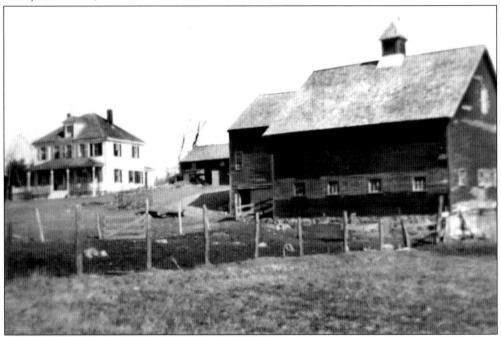

The John H. Coane farm was located on Winter Street. Coane bought 34 acres in 1907. The family raised pigs, cows, horses, chickens, turkeys, ducks, and geese. The house was originally made up of four rooms but was enlarged and remodeled several times. The original pair of large New England barns burned in 1944. (Courtesy of the Coane family collection.)

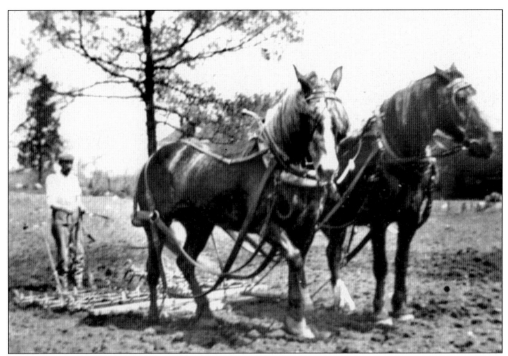

John A. Coane works with his double team of plow horses to prepare his fields for spring planting *c.* 1911. (Courtesy of the Coane family collection.)

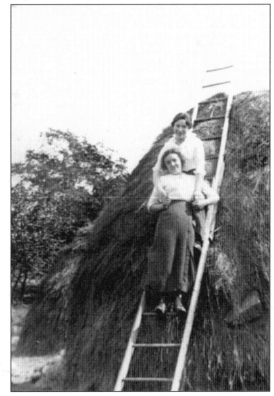

Two young women strike a romantic pose alongside a Coane farm haystack. The Coane haystacks were recognizable for their particular shape. (Courtesy of the Coane family collection.)

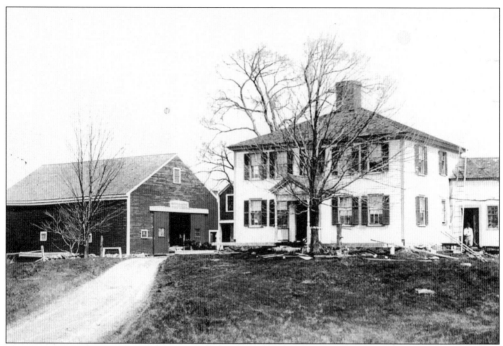

The George H. Hoar House, on Conant Road, is shown as it appeared *c.* 1875. The Hoars were 17th-century residents of Concord and one of the founding families of Lincoln. The early family members lived on Cambridge Turnpike. This house burned down and was later rebuilt and then purchased by Prescott Davis. (Courtesy of Sherman Davis.)

A 1920 vista depicts the Davis Farm (on Conant Road), owned by Gladys and Prescott Davis. Part of the farm was flooded to add to Valley Pond. (Courtesy of Ruth Davis Burk.)

A young Florence Coburn, daughter of Edward S. Coburn, feeds her pet lamb c. 1920. Lincoln children grew up with a love as well as a responsibility for domestic animals. There were approximately 170 sheep in Lincoln at the time. (Courtesy of the Coburn family collection.)

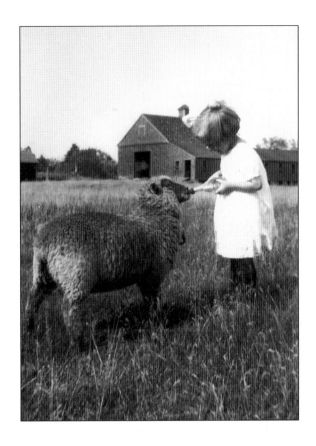

The Coburn Farm, on Tower Road, is shown in the 1980s. (Courtesy of the Coburn family collection.)

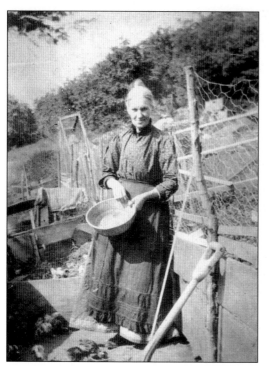

Mary Roach Flynn tends to her chicks. She and her husband, John Flynn—immigrants from Dungarvun, County Waterford, Ireland—had a farm on old County Road in East Lincoln. Part of the farm sat on Hobbs Brook, which was flooded in 1895 to create the Cambridge Reservoir. The Flynns continued to farm land on a ridge that had not been flooded. (Courtesy of Jacqueline Connair Ferro.)

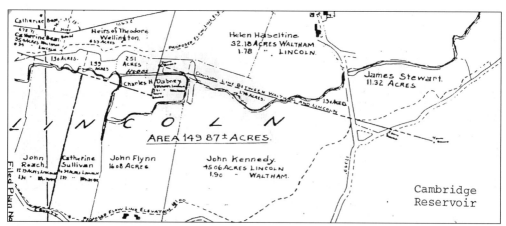

This map shows the Flynn, Roach, Kennedy, and Sullivan families' lands taken by eminent domain by the town of Lincoln to create the Cambridge Reservoir.

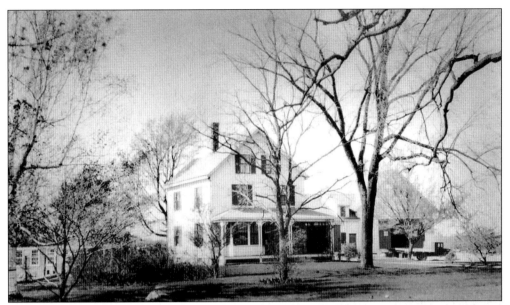

This 1928 photograph shows the Brooks-Shea farmhouse, on Bedford Road. Estelle Brooks and her brothers planned and rebuilt this house after the original Brooks house burned in 1860. The house was sold to Cornelius Shea in 1928. The farm was later sold by the Shea family and became one of the early subdivisions in Lincoln. (Courtesy of the Shea family collection.)

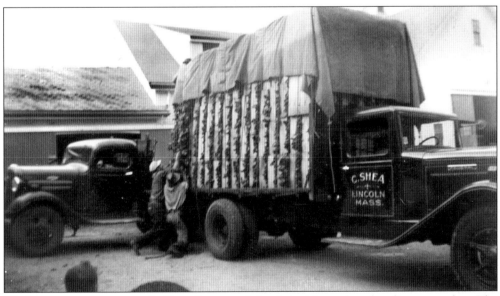

Workers secure tarps on a C. Shea Farm truck loaded with produce heading to market. The farms of North Lincoln were well known for the sizeable amounts of produce sold in the Boston markets. The Shea farm was one of Lincoln's most productive truck garden farms. (Courtesy of the Shea family collection.)

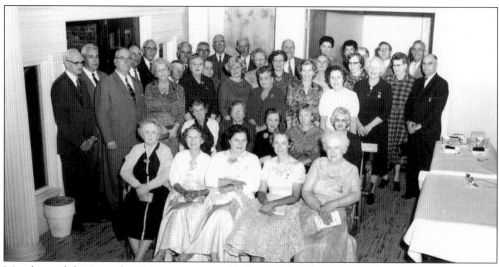

Members of the Lincoln Grange are assembled on November 14, 1960. From left to right are the following: (first row, seated) J. Hunter, E. Hunt, A. Osgood, L. Dean, and I. Blake; (first row, standing) W. Porter, R. Naylor, M. Smith, H. MacLeod, E. Kerr, E. Davis, P. Doherty, E. Courtney, and E. Doherty; (second row, seated) G. Davis, M.Coburn, M. MacLeod, unidentified, and I. Pierce; (second row, standing) E. Coburn, M. Ober, A. Oglivie, L. Bowles, E. MacKenzie, P. Davis, M. Porter, and E. Hunt; (third row, standing) A. Riley, G. Osgood, R. MacKenzie, R. Kerr, P. Davis, unidentified, J. Lennon, H. Oglivie. T. Dickson, M. Mickle, W. Dean, C. Bowles, and B. Dean. (Courtesy of the Hazel MacLeod Macinnis collection.)

Lincoln Grange Fair and Exhibition

Lincoln Garden Club Co-operating

Town Hall, Lincoln, Mass.

Saturday, Sept. 13, 1930

1.30 P. M.

Admission 10c

Worthy Exhibits Awarded Prizes
(Under competition or not)

FLOWER SHOW
In Charge of the
LINCOLN GARDEN CLUB

Committee

Mrs. M. H. Doherty, Chairman Mrs. Walter Lovejoy, Treasurer
Mrs. Sumner Smith, President Mrs. John Adams
Mrs. Robert Kinney, Vice-President Mrs. Anthony J. Doherty
Mrs. Robert Loring, Secretary Mrs. C. Lee Todd

Judge
Mr. Peter Mezitt, Weston

The Lincoln Grange Fair and Exhibition was accompanied by a printed program. (Courtesy of Sherman Davis.)

Class IV.
POULTRY, PIGEONS AND PET STOCK
Mr. Frank Lahnston, Chairman of Exhibits. Tel. 122

	Prize
1—Best trio Brahmas	$2.00
2—Best trio Orpingtons	2.00
3—Best trio Barred Rocks	2.00
4—Best trio White Rocks	2.00
5—Best trio Rhode Island Reds	2.00
6—Best trio Wyandottes	2.00
7—Best trio White Leghorns	2.00
8—Best hen of above breeds	1.00
9—Best cock of above breeds	1.00
10—Best cockerel of above breeds	1.00
11—Best pullet of above breeds	1.00
12—Best trio ducks, each variety	1.00
13—Best trio geese	1.00
14—Best trio turkeys	1.00
15—Best trio Guinea hens	1.00
16—Best trio pheasants	1.00
17—Best pair rabbits	1.00
18—Best pair pigeons (all breeds)	1.00
19—Best exhibit pet stock	.50
20—Best Tom turkey	1.00
21—Best Hen turkey	1.00
For members of 4-H Poultry Club only	
22—Best exhibit (all varieties competing)	1.00

Class V. CANNED PRODUCTS
Mrs. W. C. Burns, Chairman of Exhibits. Tel. 144-W

1—Collection of Fruits, 6 jars, of different varieties	$2.00
2—Collection of Vegetables, 6 jars, of different varieties	2.00
3—Collection of Jelly, 3 varieties, 1 glass each variety	1.00
4—Collection of Jam, Conserve and Marmalade, 3 glasses, 1 of each kind	1.00
5—Collection of Pickles, 3 varieties, 1 jar of each	1.00
6—Asparagus, 1 jar	.50
7—Tomatoes, 1 jar	.50
8—Corn, 1 jar	.50
9—String Beans, 1 jar	.50
10—Peas, 1 jar	.50
11—Carrots, 1 jar	.50
12—Beets, 1 jar	.50
13—Greens, 1 jar	.50
14—Pears, 1 jar	.50
15—Peaches, 1 jar	.50
16—Plums, 1 jar	.50
17—Berries, 1 jar	.50
18—Any other vegetable, 1 jar	.50
19—Any other fruit, 1 jar	.50

Class VI. COOKING
Mrs. J. J. Connair, Chairman of Exhibits. Tel. 273-M

1—Loaf white yeast bread	$.50
2—Loaf dark yeast bread	.50
3—Loaf quick bread	.50
4—Raised rolls (12)	.50
5—Corn bread	.50
6—Gingerbread	.50
7—Filled cookies (12)	.50
8—Dropped cookies (12)	.50
9—Cream Puffs or eclairs (6)	.50
10—Doughnuts (6)	.50
11—Chocolate layer cake	.50
12—Sponge cake or Angel food (not frosted)	.50
13—Butter cake	.50
14—Two crust pie	.50
15—One crust pie	.50
16—Milk desert (custard, puddings, etc.)	.50

The Lincoln Grange became one the leading organizations in agricultural Lincoln. It sponsored lectures on agricultural topics and held social activities. Fall Grange fairs were popular annual events. Held at the town hall, the fairs featured a traditional judging of vegetables, fruits, and handmade items. Founded in 1896, the Lincoln Grange was one of the earliest in the area. (Courtesy of Sherman Davis.)

Buttrick's ice-cream stand, on North Great Road (Route 2A), was a great favorite of Lincoln's children and their parents. It was demolished and the land is now part of Minuteman National Park. The Paul Revere plaque stands next to where Buttrick's once stood. (Courtesy of the Roland Robbins collection.)

The Precision Instruments building, on North Great Road (Route 2A), is pictured here. David Mann bought the Duds sandwich shop and dance hall, and it became Precision Instruments. Mann was a pioneer in electron spectroscopy. When he died in 1957, the building was bought by Geophysics and later sold to Minuteman National Park. In January 1965, park personnel moved their offices into the building. (Courtesy of the Mann family collection.)

Four
RECREATION, ORGANIZED AND SPONTANEOUS

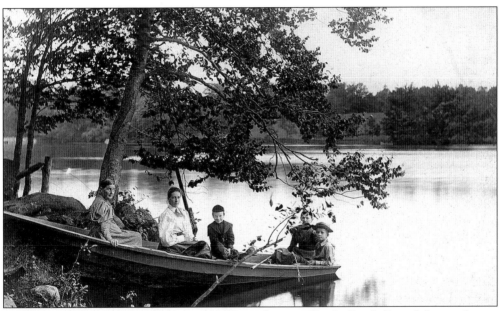

Members of the Smith family pose c. 1897 in a boat on Sandy Pond. From left to right are Mrs. Francis Smith, Mrs. Charles Smith and son Sumner Smith, Mrs. Walter Baker, and Robert. Sumner Smith's great-grandfather Jonas Smith described Sandy Pond in 1800 as one of the "pleasantest ponds." It provided fishing in both summer and winter, and it abounded with perch, pouts, eels, shiners, kivvers, and pickerel as large as six pounds. Hunting took place year-round. John Codman had a large motor launch that could carry 20 people on festive occasions. In the summer, sailboats plied the waters as well. Until it became a town reservoir, Sandy Pond provided the people of Lincoln with much year-round entertainment. (Courtesy of the Smith family collection.)

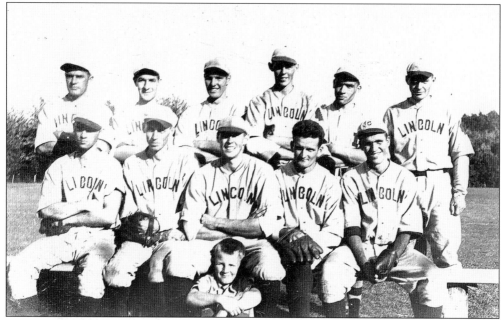

Members of the Lincoln Mohawks pose in 1934. Sitting in front is bat boy R. Meriam Jr. The others are, from left to right, as follows: (front row) E. Cunningham, L. Todd, J. Todd, W. Langille, and P. Nelson; (back row) J. Mayo, C. Mayo, A. Cunningham, D. Todd, J. Farrar, and P. Todd. Baseball was the most popular sport in town, from the time when the first game was played in 1879 to the 1950s. Men of all social classes and occupations played on Lincoln's winning teams. (Courtesy of the Lincoln Public Library.)

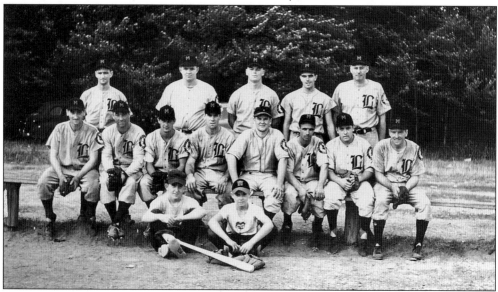

In 1949, the Lincoln Mohawks were a championship team. The bat boys in front are Bob Tracy and Jackie Smith. The others are, from left to right, as follows: (front row) Bill Holmes, Ed Cunningham, Walter Woods, John Gutinowitz, Benny Gutinowitz, Nick Macone, Pick Mulcahy, and Lew Cunningham; (back row) Al Davis, Beanie Merriam, Dave Spooner, Walter Macone, and John Todd. (Courtesy of the Lincoln Public Library.)

This patch was awarded to the Lincoln Mohawks, the 1948 champions of the Paul Revere League. (Courtesy of the Lincoln Public Library.)

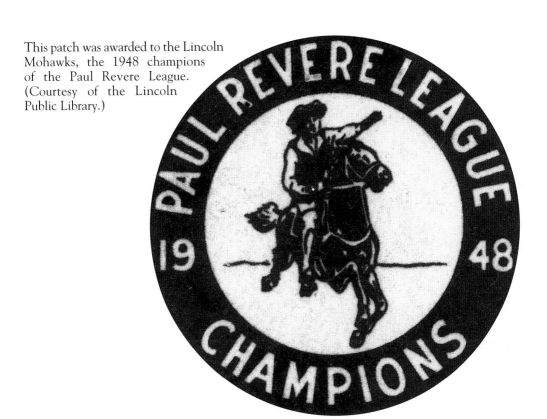

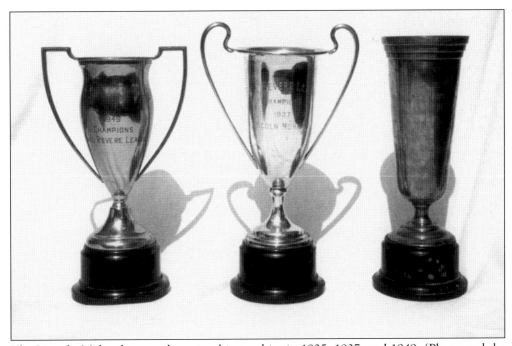

The Lincoln Mohawks won championship trophies in 1935, 1937, and 1949. (Photograph by John Glass.)

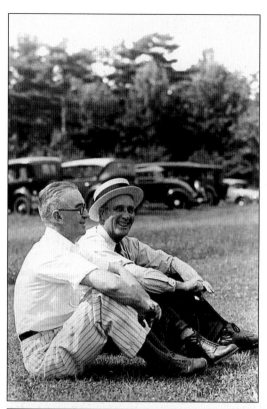

Roy Hagerty and Lincoln police chief Jerry Kelleher watch the Lincoln Mohawks play ball in 1934. (Photograph by Conrad Hatheway, courtesy of Conrad Todd.)

Spectators are shown at a Lincoln Mohawks game in 1948. Attendance sometimes reached 1,000. The whole town regularly turned out to support the home team. Jerry Kelleher (left) is still a loyal fan and police chief. (Courtesy of Roland Robbins.)

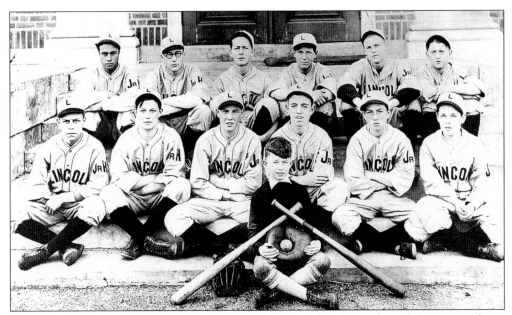

The 1929 Lincoln School baseball team is pictured here. Edward Murphy is the mascot in front. The others are, from left to right, as follows: (front row) Virgil Poland, Edward Flint, Albert Cunningham, John Edgar, Edward Cunningham, and Alan Montgomery; (back row) John Chaves, William Howard, unidentified, unidentified, Ehlert Seeckts, and Gordon Gladding. (Courtesy of the Lincoln Public Library.)

The Lincoln School baseball team was the league champion in 1951. The team members are, from left to right, as follows: (front row) Dave Donaldson, Rob Todd, George Gordon, Dimitri Alfonsky, and Al Dougherty; (back row) Charlie Crane, Andy Taylor, Murray Mills, John Hurd, Franie Smith, Dick Tandy, Harry Warner, and Dick Robbins. (Courtesy of the Lincoln Public Library.)

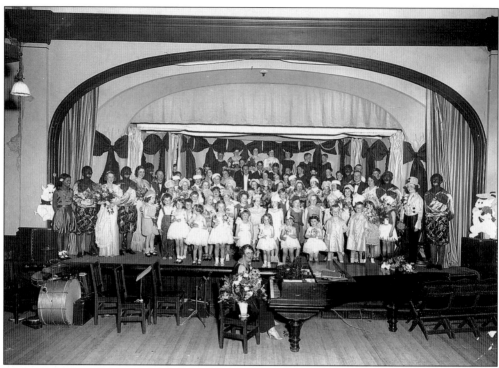

Ruth Wetherbee was pianist for and director of the ensemble cast of the annual town minstrel show, sponsored by St. Anne's Church in the early 20th century. William Davis, in charge of the Gordon kennel, was always the master of ceremonies; Conrad Hatheway played the banjo. (Courtesy of the Walter Wood collection.)

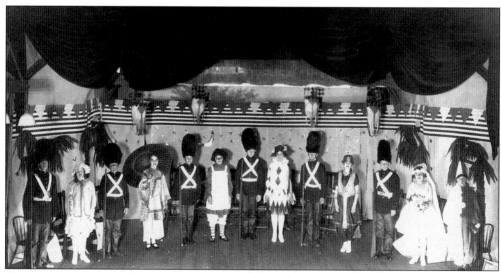

These players in the minstrel show in 1923 are, from left to right, Elliot Bunker, Eva Johansen, Webster Holt, Mabel Hatheway, Robert Balch, Evelyn Brown, Everett Chute, Leslie Adams, Francis Balch, Lois Harrington, John Todd, Edna Sherman, and Duncan Chapman. (Courtesy of the Lincoln Public Library.)

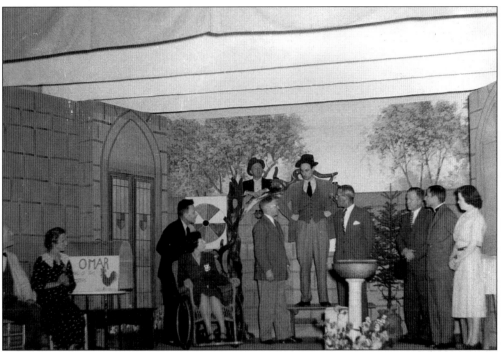

A scene in the Lincoln Players 1951 production of *The Silver Whistle* is captured here. The actors are, from left to right, Norman Fradd (partially visible), Dorothy Murphy, Williams Holmes, Lucy Bygrave, Ed Rooney, Sumner Smith, Harrison Hoyt, John Wilson, Leonard Larrabee, David Rogers, and Mabel Todd. (Courtesy of the Lincoln Players collection.)

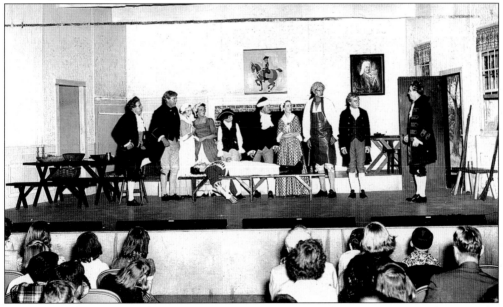

For celebrations in 1954, Harriet Rogers wrote *The Winklehawk*. Harrison Hoyt is lying on the bench. From left to right are Clement Sawtell, David Todd, Harriet Rogers, Barbara Garrison, Douglas Ashworth, Norman Fradd, Martha DeNormandie, A. Robey, Louis Paddock, and Fred Walkey. (Courtesy of the Lincoln Public Library.)

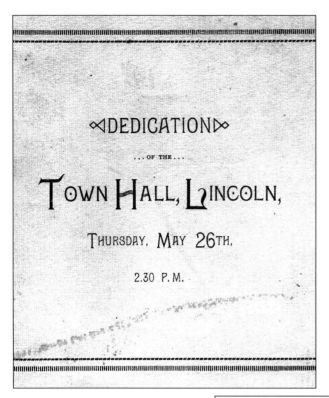

⋈DEDICATION⋈

... OF THE ...

TOWN HALL, LINCOLN,

THURSDAY, MAY 26TH,

2.30 P.M.

This program was printed for the dedication of the new town hall on May 26, 1924. The hall was the gift of George F. Bemis, who left $20,000 for its construction and an additional $30,000 in endowment for "an annual course of public lectures, of an instructive and elevating character." The Bemis Lecture Series continues to this day. (Courtesy of the Lincoln Public Library.)

The Bemis Lectures

THURSDAY EVENING, APRIL 18

DR. RUSSELL H. CONWELL

The Dean of American Lecturers

Subject to be announced

❦❦❦

FRIDAY EVENING, APRIL 26

THE CELLA-TAK-DEMAILLY TRIO

Theodore Cella, Harp
Eduard Tak, Violinist } Members of the Boston Symphony Orchestra
Charles Demailly, Flute

Assisted by

Lillian Hamilton Thornquist, Contralto

This program for the 1918 Bemis lectures indicates the featured speakers. More recent speakers have been Helen Caldicott, Dave Cowens, Robert Frost, Margaret Mead, Daniel Patrick Moynihan, and Julie Taymor. (Courtesy of the Lincoln Public Library.)

Two town fathers, Tom Adams and Sumner Smith, converse during a town meeting. (Photograph by Norman Hapgood.)

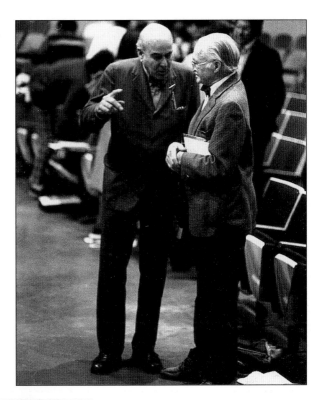

Quincy Adams, attired for his daughter Lee's wedding in June 1961, attends to a few chores before leaving for the ceremony. (Courtesy of the Lee Weaver collection.)

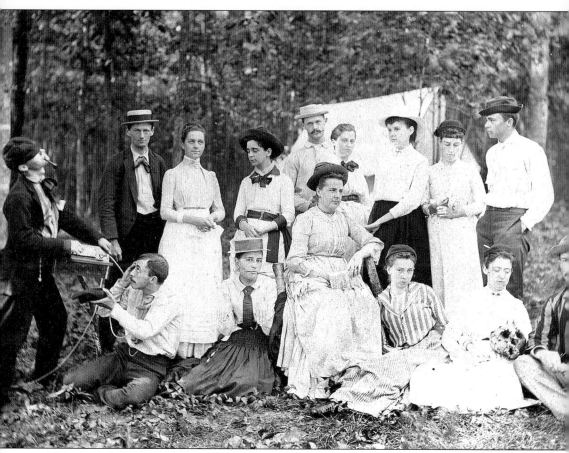

A group frolicks on Fairhaven Bay in September 1899. Shown are Harry Russ (left, playing the hand organ) and George Baldwin (sitting, holding out the hat). Known to be in the first row are Mary Meyers, Mrs. Simonds (the chaperone), Helen Fauhenier, Lucia Campbell, and Frank Bacon. Standing are, from left to right, Irving Smith, Elsie Pierce, Abbie Pierce, Frank Kidder, Adeline Campbell, Ethel Kidder, Fanny Campbell, and Robert Baldwin. (Courtesy of the Lincoln Library collection.)

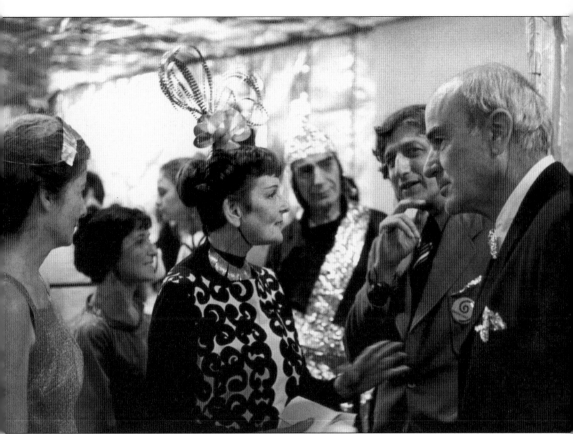

Ilse Gropius, wife of famous architect Walter Gropius, hosts a "Grope Fest" for the architectural firm TAC. From left to right are Mrs. Tom Adams, Mrs. Archangelo, Dean Cascieri, Harris Barron (director of Zone), and Tom Adams. (Courtesy of the Adams family collection.)

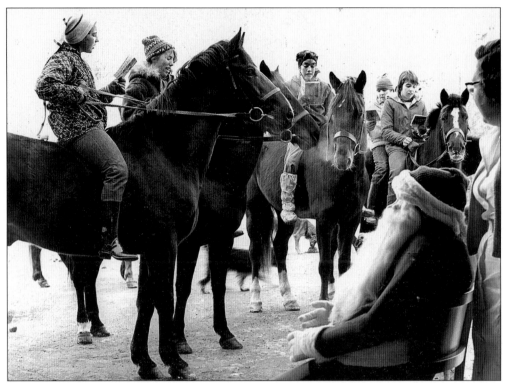

The Lincoln 4-H horse group holds a Christmas celebration with Perry Culver as Santa Claus. On horseback are Ellen Powell, Sally Kindleberger, Lisl Donaldson, Nancy Bergen, and Shelly Culver. (Courtesy of the Bergen family collection.)

A 4-H group rides to Storrow House to sing Christmas carols for convalescent patients. On the left are, from front to back, Nancy Bergen and Ellen Powell. On the right are, from front to back, Amy Faunce, Becky Crawford, Sally Kindleberger, Josie Winship, and Lydia Donaldson. (Courtesy of the Bergen family collection.)

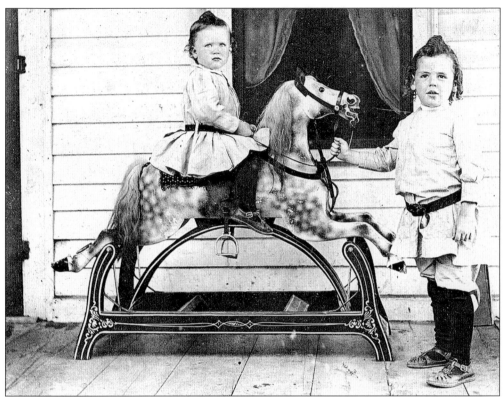

Robert Donaldson Jr. and Malcolm Donaldson play with their hobbyhorse on the porch of the Donaldson house, on Old Lexington Road, in 1906. (Courtesy of the Donaldson family collection.)

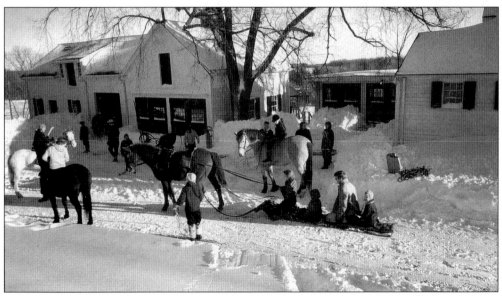

Riders Emily Sisson and Edie Garrison are shown with Red Pepper ready to pull the toboggan. Red Pepper is driven by Peggy Flint. On the toboggan are, from left to right, unidentified, Collin Sanderson, and Abby Flint. (Courtesy of the Polumbaum collection, the Lincoln Public Library.)

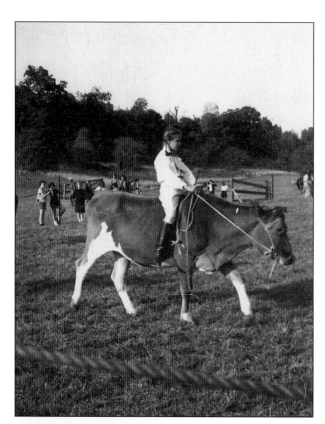

At the Matlock Horse Show in October 1953, Peggy Flint, for want of a horse, is riding her cow, Golden, in a game of musical chairs. Peggy took second prize. (Courtesy of Peggy Flint Weir.)

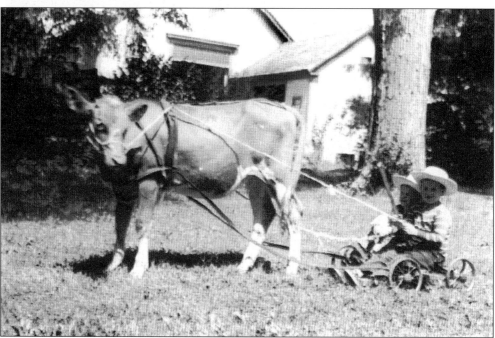

Peggy Flint turns her cow into a draught animal for her brothers Warren and Ephraim. (Courtesy of the Flint family collection.)

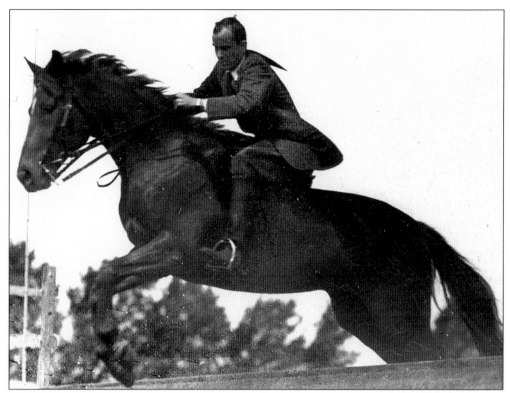

Tom Adams, on Alec, takes a jump at a local horse show. The horse was a grandson of the great Man-o'-War and was a gift from Alec Higginson. (Courtesy of the Adams family collection.)

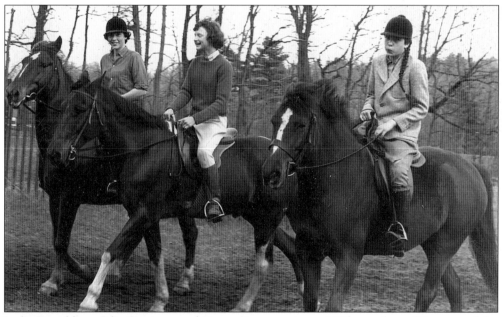

Lydia Donaldson, Edie Garrison, and Nancy Bergen enjoy a 4-H horse show. (Courtesy of the Bergen family collection.)

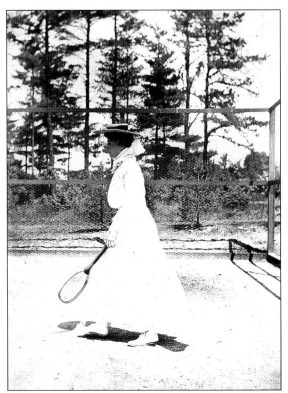

An early-20th-century guest of the Adams family, attired for tennis, awaits a serve. (Courtesy of the Adams family collection.)

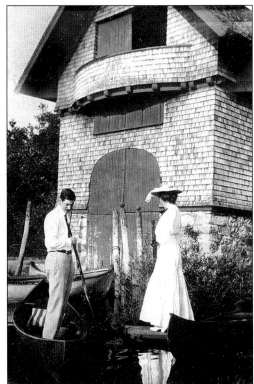

Henry Adams and Ethel Cryder push off from the C.F. Adams family's boathouse for an afternoon canoe ride on Fairhaven Bay. (Courtesy of the Adams family collection.)

The Adams boys are ready for hockey on Baker Pond. They are, from left to right, Doug, Peter, Henry, and John Adams. (Courtesy of the Adams family collection.)

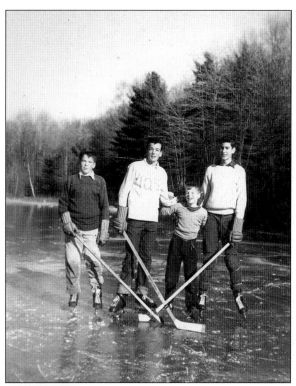

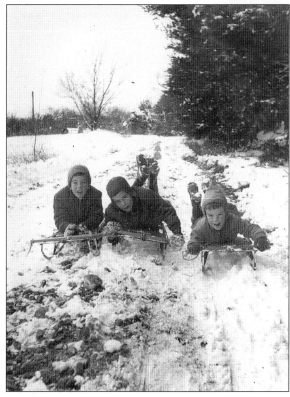

Three Adams boys—Peter, John, and Dougie—are captured sledding on the Adams property off Baker Bridge Road in 1948. (Courtesy of the Adams family collection.)

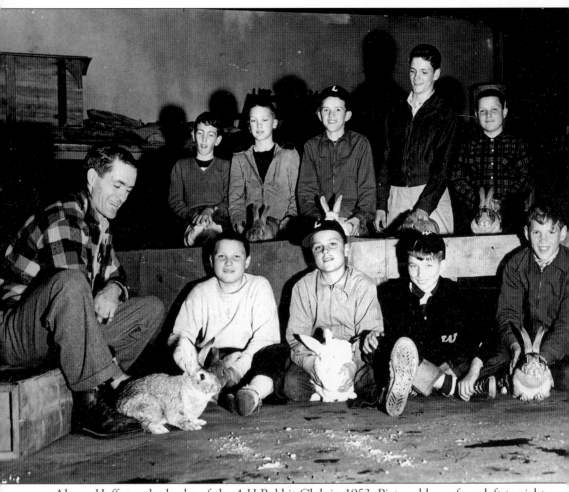

Almon Huff was the leader of the 4-H Rabbit Club in 1953. Pictured here, from left to right, are the following: (front row) R. Laurent Cannon, Walter Cannon, Robert Ross, and Danny Donaldson; (back row) Bruce Bergen, Elliot Pierce, Carleton Huff, David Donaldson, and Philip Cannon. (Courtesy of Janet Huff Cutler.)

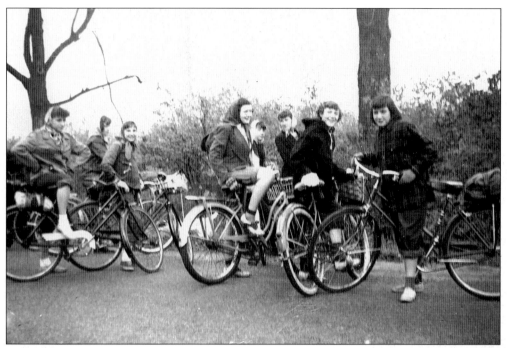

Girl Scout leader Elizabeth Snelling took her Scouts on a 1949 bicycle trip. Pictured here are Sheila Dougherty, Susan Sherman, Julie Davis, and Sarah Cannon. (Courtesy of Elizabeth Snelling.)

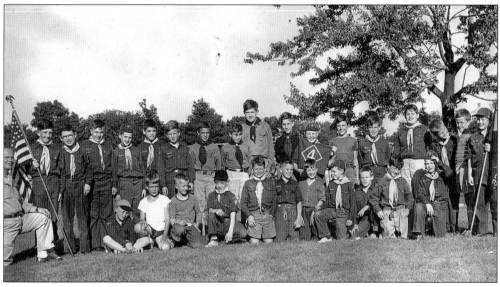

These local Boy Scouts are, from left to right, as follows: (front row) Dick Kelly, Jim Wilson, Charlie Snelling, Bill Deford, Carlo Forbes, Francis Smith, Murray Mills, Rob Todd, Dick Robbins, Joe Britt, and Chris Billings; (back row) Scoutmaster Phil Davis, Jackie Smith, John O'Reilly, George Patterson, Steve Spooner, John Hurd, Andy Taylor, Dana Murphy, Bill Fleck, Parker Spooner, Curtis Chapin, Jim Pallotta, Mike Bliss, Dick Dumback, Paul Dodson, Harry Warner, Jeff Eaton, and Nick Fleck. (Courtesy of the Lincoln Public Library.)

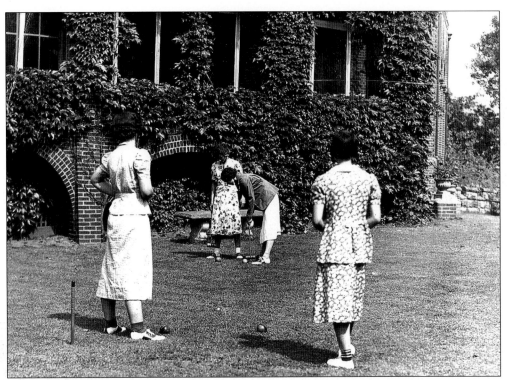

The DeCordova Museum grounds were a good place for a game of croquet. (Courtesy of the Lincoln Public Library.)

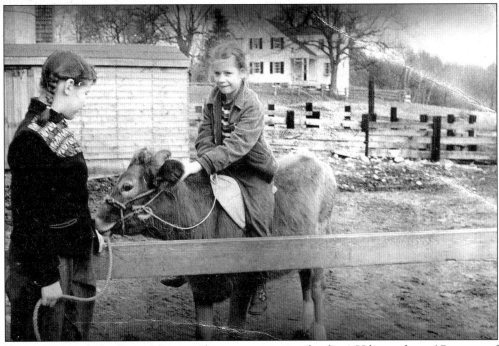

Nancy Carmen helps Peggy Flint astride a cow, preparing for the 4-H horse show. (Courtesy of the Flint family collection.)

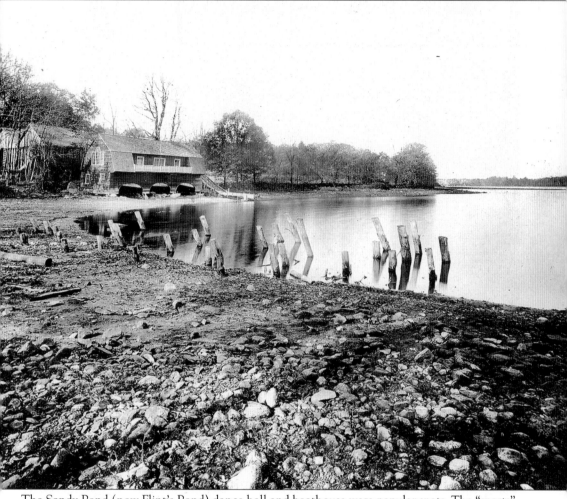

The Sandy Pond (now Flint's Pond) dance hall and boathouse were popular spots. The "sports" of Lincoln, the social crowd, maintained the dance hall and boathouse on the shore near the road, where they kept boats and often partied. (Courtesy of the Lincoln Public Library.)

For countless years, the Waverly Post of Belmont, a marching band, animated Fourth of July parades. Here, in 1975, the band plays an afternoon concert on the school grounds. (Photograph by Ted Polumbaum, courtesy of the Lincoln Public Library.)

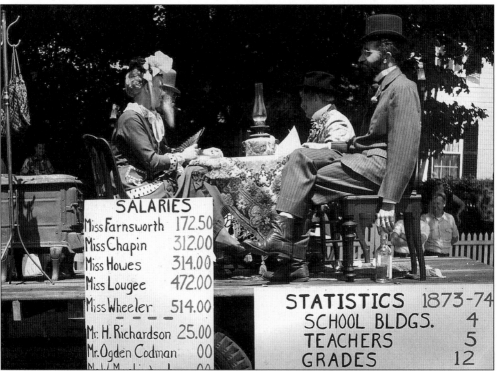

SALARIES
Miss Farnsworth 172.50
Miss Chapin 312.00
Miss Howes 314.00
Miss Lougee 472.00
Miss Wheeler 514.00

Mr. H. Richardson 25.00
Mr. Ogden Codman 00

STATISTICS 1873-74
SCHOOL BLDGS. 4
TEACHERS 5
GRADES 12

The 1954 parade float of the school committee was designed to depict the committee's financial dilemma. The parades uniquely allowed individuals and committees to air their grievances and vent their frustrations, providing much fun for spectators. (Photograph by Don Robinson, courtesy of the Lincoln Public Library.)

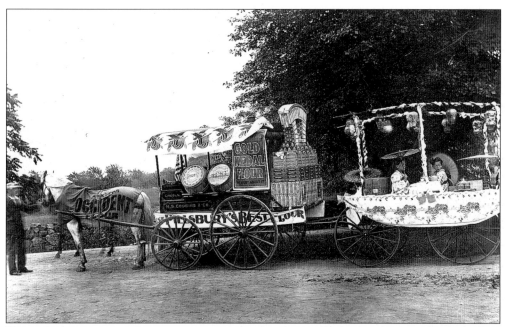

Henry Cousins, owner of a grocery store at the depot, proudly displays his Fourth of July float
c. 1900. (Courtesy of the Lincoln Public Library.)

This photograph was taken on July 4, 1900, during a sporting event held at the town ball field,
which was then at the southwest corner of Codman and Lincoln Roads (at that time, called
Blodgett's Corner).

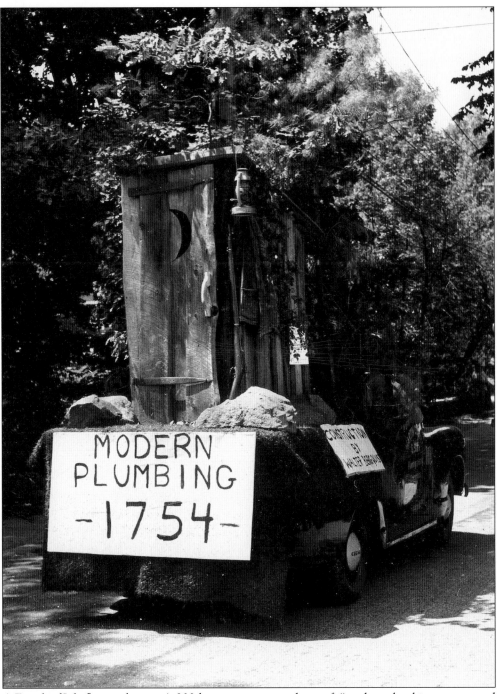

A Fourth of July float at the town's 200th-anniversary parade spoofs "modern plumbing constructed by Walter Gropius." (Photograph by Don Robinson, courtesy of the Lincoln Public Library.)

Five
ESTATES AND OPEN SPACE

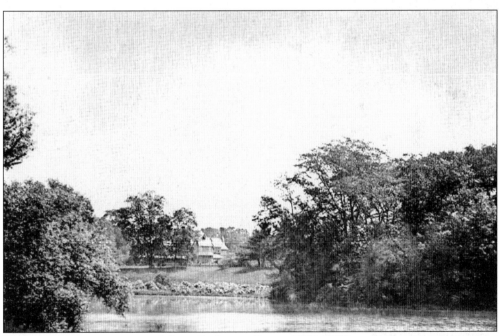

The Burnham estate is viewed from Fairhaven Bay c. 1900. William K. Burnham bought the Baker farm, consisting of about 300 acres, from James E. Baker, the last of his family line. Burnham built this house in the meadow at Fairhaven Bay. There had been an earlier Baker farmhouse on the site at one time. Burnham hired the Frederick Law Olmstead firm to supervise the layout and plantings. Construction began in the spring of 1889; Shaw and Hunnewell were the architects. The house stood on a large terrace of solid masonry on the Sudbury River. A boathouse stored several boats and a steam launch. (Courtesy of the Kim Johnson collection.)

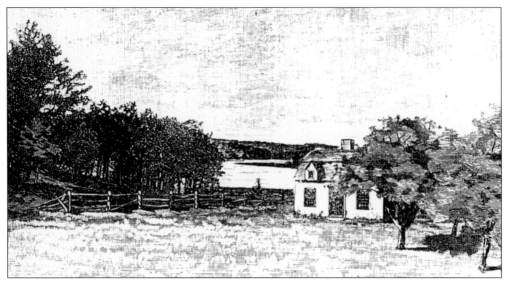

The Baker farmhouse sits on Fairhaven Bay. Ralph Waldo Emerson described the farm in 1848: "James Baker does not imagine that he is a rich man, yet he keeps from year to year that lordly park of his by Fairhaven Pond lying idly and nobly open to all comers without crop or rest . . . with its hedges of Arcady, its sumptuous lawns and slopes, the apples on its trees, the mirror at its foot." The house was torn down in 1866. William Ellery Channing wrote a poem about it: "Baker Farm / Thy entry is a pleasant field, / Which some mossy fruit-trees yield. . . . O Baker Farm! / There lies in thee a fourfold charm." (Courtesy of the Concord Free Public Library.)

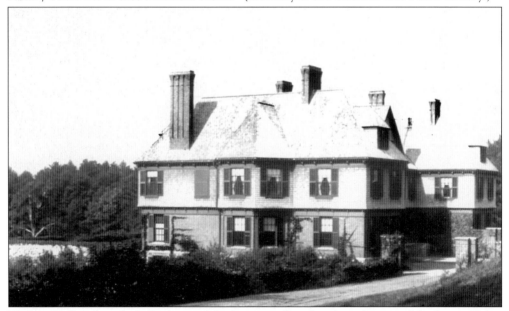

William K. Burnham built Fairhaven (also known as Burnham) on the site of the former Baker house. The home was built in a modified Queen Anne Revival style. The lower story was brick, and the second story was covered in dark shingles. Fairhaven contained 15 bedrooms and a water-powered elevator. There were standpipes on the lawn for watering grass and flowers. The Burnhams sold the property to C.F. Adams Jr., grandson of Pres. John Quincy Adams. (Courtesy of the Lincoln Public Library.)

104

This portrait of C.F. Adams Jr. was done in 1904. Adams bought the Burnham house and knew A.H. Higginson's father from the Civil War. The estate was a great pleasure to him, and he continually added to his holdings. President of the Massachusetts Historical Society, he was the keynote speaker at the 150th anniversary of the town of Lincoln. He and his wife, the former Mary Ogden, had two sons, John and Henry, born in 1875. Henry never married; John's children were the heirs of C.F. Adams Jr. (Courtesy of the Adams family collection.)

Snow-laden pines grace the Adams property in the winter of 1901. While the Olmstead firm was working on the property, its tree plantings were reported in local papers. Seven acres of white pines, 15,000 trees, were set out on the Burnham property. In June 1901, it was noted that C.F. Adams had finished two delightful bridle paths through the woods and partly in view of the bay. Whereas Olmstead planted white pines, Adams liked and added hemlock. (Photograph by Herbert Gleason, courtesy of the Concord Free Public Library.)

John Adams gathers at Burnham with friends in 1902. From front to back are John Adams, F.N. Forbes, F. Ames, and W.E. Ladd. (Courtesy of the Adams family collection.)

John Adams, the son of Charles Francis Adams Jr. and Mary Ogden Adams, is shown next to a sketch of John Adams's ancestor Abigail Adams. John Adams married Marion Morse. (Courtesy of the Adams family collection.)

In this 1901 photograph, John Adams poses with companions at Burnham. (Courtesy of the Adams family collection.)

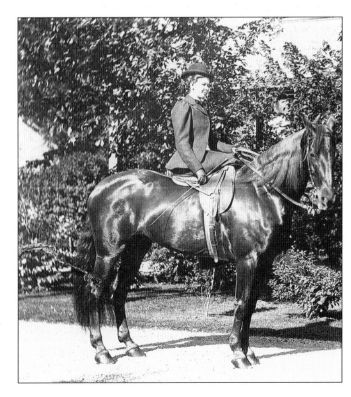

Marian Morse, the wife of John Adams, rides Bruny. Her father, C.F. Morse, served in the Civil War with Charles F. Adams Jr., and they were business partners. (Courtesy of the Adams family collection.)

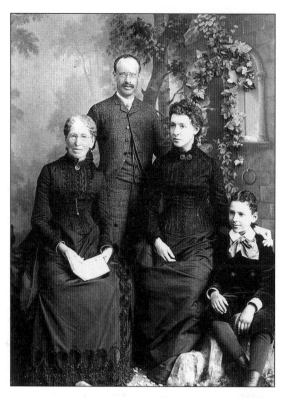

This family portrait features Mrs. Thomas Dana, Julian DeCordova, Lizzie Dana DeCordova, and Julian Dana DeCordova (known as Dana). Julian DeCordova Sr.'s neighbor Sumner Smith described DeCordova as an eccentric character. DeCordova was complex, tricky, fascinating, gifted, and talented—in a way. As a young man, he traveled to Asia on a boat journey that took four weeks. He became an expert tea trader. After he had earned $30,000, he decided to ask Thomas Dana for his daughter in marriage. Dana agreed, and the couple went to England for their wedding. (Courtesy of the DeCordova Museum and Sculpture Park.)

This photograph shows the entrance to the home of Julian and Lizzie DeCordova in 1917. Thomas Dana, formerly the partner of George Grosvenor Tarbell, continued to manage a wholesale provision firm. Frequently, the employees summered in Lincoln. In 1881, the family bought 20 acres of Weston family land bordering Flint's Pond. Before the family began its art collection, the property was known as a fine arboretum. (Photograph by Herbert Gleason, courtesy of the Concord Free Public Library.)

The towers of the DeCordova Castle can be seen here. In 1930, the town accepted Julian DeCordova's gift of 29 acres on Sandy Pond with his residence, art gallery, and endowment as the "DeCordova and Dana Museum." The gallery, connected to the house with an enclosed arched bridge, was flanked with towers and topped with battlements. The DeCordovas built their home on an elevation Henry David Thoreau had called "Three Friends Hill" for Ralph Waldo Emerson, William Channing, and himself. DeCordova opened his gallery to the public each summer. The contents, professionally appraised, were deemed unworthy of the testator's purpose and were auctioned. It became a museum of contemporary art. (Courtesy of the DeCordova Museum and Sculpture Park.)

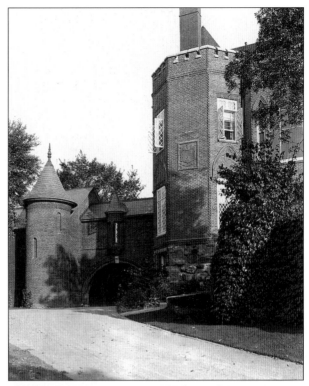

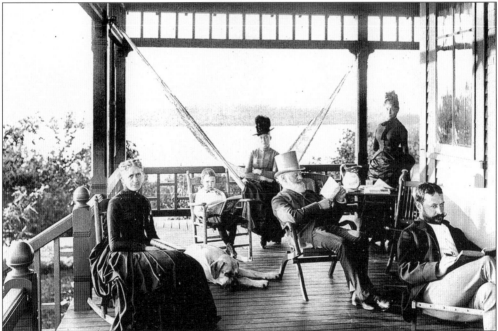

DeCordova family members and friends are gathered on the DeCordovas' porch, with Flint's Pond in the background. The porch was removed and the house was altered to become a castle. Mrs. Thomas Dana is at the lower left, and Julian DeCordova is at the lower right. (Courtesy of the DeCordova Museum and Sculpture Park.)

The

Compass

Winter 1999

So much of what we are is due to others . . .

who could see farther,

who could dream beyond the limits of their vision,

and who could somehow foresee what might be.

This cover from the *Compass,* an educational periodical, depicts Helen Storrow and a painting of her Lincoln home on Baker Bridge Road, completed in 1905 to entertain Jim Storrow's 20th reunion with his Harvard Class of 1885. A hardy couple who met while mountain climbing in Switzerland, the Storrows built a large, durable, fireproof home. Together they were responsible for the dam that converted the Charles River into a tideless basin and water park and for Boston's Storrow Drive. Helen's trustees sold Storrow House in 1945 to Massachusetts General Hospital as a rehabilitation site. Later, the house was sold to the Carroll School for dyslexic children. (Courtesy of the Carroll School.)

110

Helen Storrow poses in her Girl Scout uniform. In Lincoln, she entertained Lord and Lady Baden-Powell and Juliette Low. Storrow was a major sponsor of Girl Scouting. She started leadership training and gave campgrounds and the international Scout house Our Chalet, in Switzerland. She sponsored a troop of Morris dancers and a branch of the English Folk Dancing Society. Working with children in Boston, she funded Saturday Evening Girls and those who made Paul Revere Pottery. (Courtesy of the Flint family collection.)

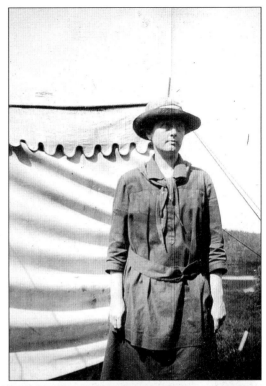

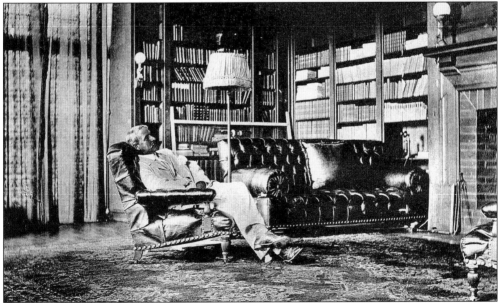

Jim Storrow relaxes in his library, the Growlery. His sport was rowing; he was captain of the Harvard crew that beat Yale by 22 lengths. He worked with underprivileged boys at Boston's West End house and served as fuel administrator for New England during World War I, while Helen's dance group performed at war bond rallies. Jim worked to train Boy Scout leaders and served a term as the organization's national president. For his work reorganizing General Motors, he was well rewarded. He died in 1926. (Courtesy of the Lincoln Public Library.)

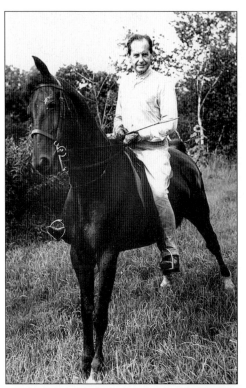

Walter Gropius rides horseback *c.* 1940. Gropius was director of the Bauhaus in Germany from its founding in 1919 to 1928. When the political climate in Europe deteriorated, Gropius accepted an appointment at Harvard. He and his second wife, Ilse, with their daughter Beate, arrived in Cambridge in 1937. Gropius wanted to build in Lincoln. No bank would finance the innovative house he designed. Henry Shepley, an architect they knew, approached Helen Storrow; she gave the land and financed the construction, which Gropius repaid as rent. (Courtesy of the Society for the Preservation of New England Antiquities.)

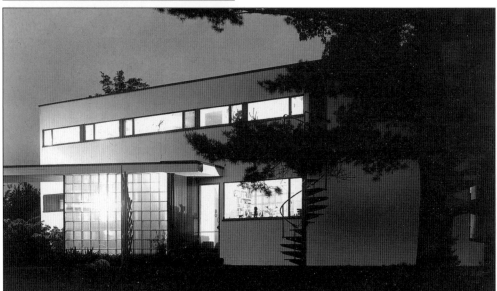

The Gropius House sits at 68 Baker Bridge Road. Gropius wanted his house to fit in the landscape and used clapboards, innovatively, flush and vertically. To prove that flat roofs did not require the maintenance of downspouts and gutters, he slanted the roof to an inner drain. The interior plan is light and open, and in summer, the air circulates freely. Ilse Gropius bequeathed the house to the Society for the Preservation of New England Antiquities, which opened it to the public in 1987. (Photograph by David Bohl, courtesy of the Society for the Preservation of New England Antiquities.)

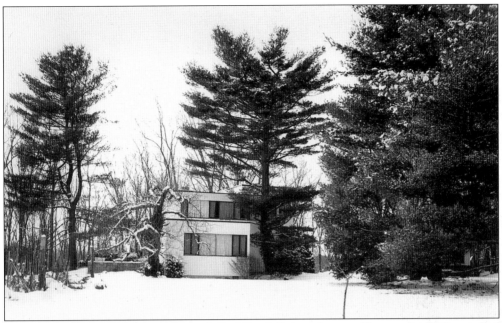

The Marcel Breuer house sits on Woods End Road. Breuer, born in Hungary in 1902, enrolled in the Bauhaus in 1920 shortly after its formation. He was brought to Harvard by Walter Gropius. Helen Storrow gave Breuer the land and financed the construction, as she had done for Gropius. (Courtesy of the Lincoln Public Library.)

Marcel Breuer (1902–1981), Mrs. James Plaut, James Plaut, Frank Lloyd Wright (1867–1959) and Walter Gropius (1883–1969) are posed at Gropius's house in Lincoln in 1940. Gropius and Breuer were probably showing off their innovative houses on Baker Bridge and Woods End Roads, the first of the International School to be built on the East Coast, to their colleague Wright, whose prairie homes were an original contribution to contemporary architecture. (Courtesy of the Society for the Preservation of New England Antiquities.)

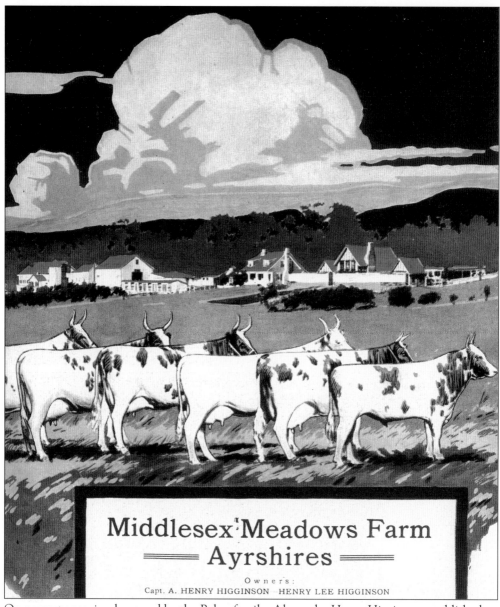

Middlesex Meadows Farm
Ayrshires

Owners:
Capt. A. HENRY HIGGINSON - HENRY LEE HIGGINSON

On property previously owned by the Baker family, Alexander Henry Higginson established an ambitious farm. Known as Middlesex Meadows, it was located on what is now known as Baker Farm Road. Higginson bred Ayrshire cattle, importing a sire costing a record $15,000 from Scotland. He also maintained a piggery, a stable for horses used in fox hunting, and a foxhound kennel. Higginson was an ardent sportsman, a career supported by his father. This illustration is from a color advertisement in an agricultural magazine c. 1920. (Courtesy of the Adams family collection.)

A. Henry Higginson is pictured here. After graduating with the Harvard Class of 1896, Higginson first lived in a house on Baker Bridge Road. His father, Henry Lee Higginson, founder of the Boston Symphony, had been a friend of Charles Francis Adams since the Civil War. His great-uncle Stephen Higginson had married Storrow's great-aunt Louisa. Jim Storrow was a partner of Higginson's father in the Lee Higginson firm. (Courtesy of the Glass family collection.)

A. Henry Higginson is captured here with his foxhounds. He once described the Middlesex Hunt as a small but select body of cavalry, in uniforms now green, now red, that rode through the countryside to hunt at some danger to their lives and limbs. As the hunt raced through Higginson, Storrow, Warner, Codman, and Snelling lands, the town was roused by the call of the horns. One small boy heard the clamor of the chase and, fearing he would be considered fair game, climbed a tree. Toward the end of his life, Higginson was a master of foxhounds in England. (Courtesy of the Glass family collection.)

This view of the Higginson property shows some of the auxiliary buildings of Middlesex Meadows. Higginson built a track to be used for his two annual shows. In the spring, he held a puppy show, and each October he put on the Annual Horse Show of the Middlesex Hunt, held at his South Lincoln Kennels on a Saturday from 10:00 a.m. to 5:00 p.m. (Courtesy of the Lincoln Historical Society.)

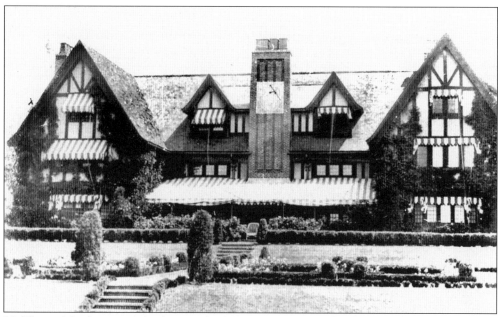

Middlesex Meadows was the home of A. Henry Higginson. Julian I. Chamberlain was the architect for the early-20th-century English Tudor home. A substantial house, it was situated on Henry David Thoreau's pine or bare hill. The estate caught the eye of Don Henley, a contemporary musician and Thoreau enthusiast. Henley raised money to buy and preserve the area that Thoreau had chronicled. About 100 acres and the Higginson house were purchased. Henley founded the Thoreau Institute and Walden Woods Project, dedicated in 1998. The stable, kennels, and other outbuildings, now remodeled, are still occupied. (Courtesy of the Glass family collection.)

This catalog for horse show on October 17, 1908, indicates that competitions were held in many categories: ladies driving, combination, saddle, pairs, and a half-dozen hunter classes. Ribbons and often cups were awarded winners. John Todd remembered his father won an umbrella and cigar race at one show. The mounted contestants tried to light the cigar while carrying an umbrella and riding around a half-mile course. The one who finished first with the cigar lit was the winner. (Courtesy of the Seeckts family collection.)

CATALOGUE

.. OF THE ..

NINTH ANNUAL

HORSE SHOW

———— OF THE ————

MIDDLESEX HUNT

HELD AT

THE KENNELS, SOUTH LINCOLN

Saturday, October 17th, 1908

Marion Ehlert poses with Babe. The two won the combination horses class at the 1908 Middlesex Horse Show. Another year, the featured race was with a pig. A.H. Higginson boasted that his pig could outrun any human. Thomas King of Maynard accepted the challenge. When King won by a yard, a lady with champagne glass in hand came up wanting to congratulate the champion runner, and she kissed him lightly on the cheek. He learned she was Amelia Galli-Churci, the greatest operatic diva of the day. (Courtesy of the Seeckts family collection.)

Louise Ayer Gordon Hatheway is accompanied by her terriers Weezie, Dina, and Ruffles. In 1904, she married Donald Gordon, and in 1912, they decided to construct a new home, Gordon Hall. Frank Chouteau Brown, their architect, used red brick roofed with thick slate, similar to Oxford University buildings. Brown, with Duncan Chapman, the Gordons' farm manager, supervised the contractor, R.D. Donaldson of Lincoln. After Donald Gordon's death in 1913, Louise Gordon married Conrad Hatheway. She left her estate in 1954 to the Massachusetts Audubon Society, endowing it to fulfill broad educational and recreation purposes. (Courtesy of the Massachusetts Audubon Society.)

The courtyard of Gordon Hall was planted with peonies, lilies, lavender, and white wisteria. The stone of the entrance walk contains fossils. Inside, a divided stairway is papered with Chinese wallpaper similar to that at the Governor's Palace in Williamsburg, Virginia. The dining-room ceiling is a replica of one at Mount Vernon. The living room with bookcase-lined walls accommodates 250 to 300 people. Upstairs, each bedroom had its own bath. The basement had darkrooms and workshops. (Courtesy of the Todd family collection.)

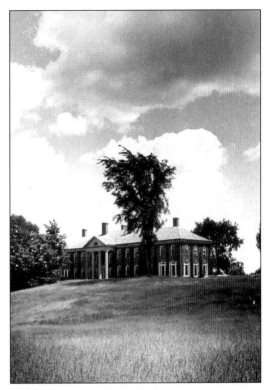

The sunroom of Gordon Hall is floored in decorative tile. A bronze wall fountain has a sculptured likeness of the head of Meagan, one of the Gordons' prize Welsh terriers. In the yard, well-equipped kennels housed the terriers. This building, of red brick with a slate roof, has an office, an operating room, tiled bathing and combing areas, and numerous runs. There was a turkey house where wire pens were raised above the floor to keep the birds free of disease. The poultry house was planned to accommodate 600 hens. (Courtesy of the Todd family collection.)

Farm hand Lloyd Douty introduces children to a workhorse. Douty came to Drumlin Farm as a herdsman in 1953. At that time, all the work was done by hand and horse. There was no truck or hay baler. The five cows were milked by hand, and all the hay was put in the barn by hand. (Courtesy of the Massachusetts Audubon Society.)

Children tour the New England farm scene at Drumlin Farm. In time, Mrs. Hatheway's farm became a model New England farm. One day, a school group in Arlington asked her if schoolchildren could see the farm. When questioned, her staff replied they would be happy to show the farm. So successful was the first tour that many followed. Mrs. Hatheway wanted children to enjoy the farm life, crops, and animals so that they could learn the necessity and value of good conservation practices. (Courtesy of the Massachusetts Audubon Society.)

William Davis (left) converses with John Todd at Davis's retirement party in December 1968. An Englishman, Davis was brought to this country by Louise and Donald Gordon to train and care for their prize terriers. He served as tax collector and as town clerk for many years. John Todd (1910–1980), a Boy Scout leader and Lincoln thespian, also served two terms as selectman. At his death, he added to the endowment fund of the Bemis Lecture Series. (Courtesy of the Lincoln Public Library.)

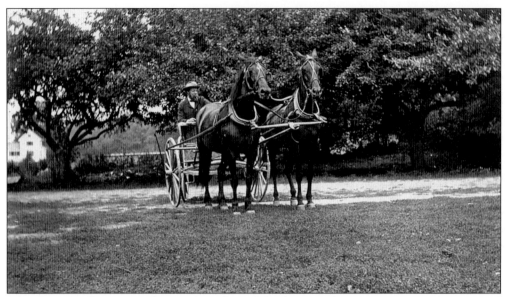

S. Rodman Snelling is seen here in Lincoln with his horse and carriage in 1906. He ran a coal and ice business with icehouses on Beaver Pond. His descendants continue to live in Lincoln. Like his father, he was a senior warden of St. Anne's Church. His father, Howard Snelling Sr., was the first major late-19th-century landowner from Boston to acquire property in Lincoln. His property, which extended from Route 126 to the Sudbury River, is now known as Mount Misery. He donated land to build St. Anne's Church. (Courtesy of Elizabeth Snelling.)

Howard Snelling Jr. is shown here at Camp Townsend, Peekskill, New York, in August 1898 during the Spanish-American War. He was the younger son of Howard Snelling Sr. One year, he rode with the Middlesex Hunt mounted not on a horse but on a mule named Bat Ears. The braying of the mule not only woke the countryside but terrified the hounds. Later, he settled in Ashville, North Carolina. (Courtesy of Elizabeth Snelling.)

Baker Bridge Road is seen here in winter. The double row of maple trees was planted by the Bakers in the 1890s. (Photograph by David Webster, courtesy of the Lincoln Public Library.)

In 1937, two of Howard Snelling's grandchildren, Jackie and Sally Stone Snelling, perch on the rock in Sudbury River at the river's narrowest place, Bound Rock. It is the three-town boundary point for Wayland, Concord, and Lincoln. (Photograph by Herbert Gleason, courtesy of the Concord Free Public Library.)

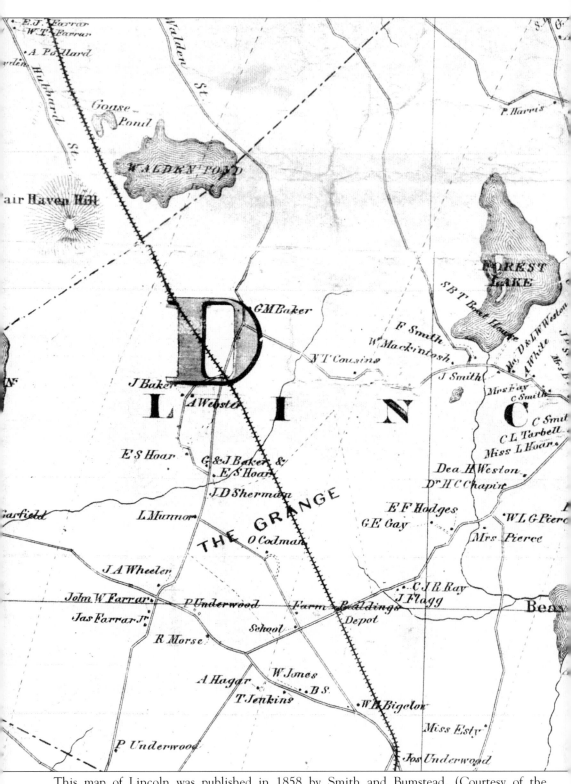

This map of Lincoln was published in 1858 by Smith and Bumstead. (Courtesy of the

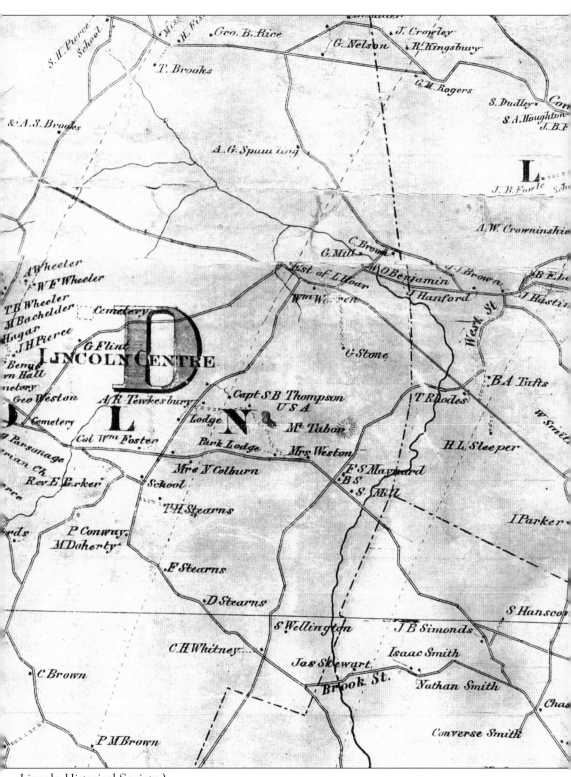

A member of Lincoln's Land Conservation Trust, Quincy Adams is seen holding a dahlia. When the town voted to buy 100 acres from the Ricci family, the trust realized it had been done without any planning on its part. Quincy invited Bob Lemire, a new member, to see the trail conservation map. They started with Charles W. Eliot and Morton Braun's 1958 report, *Planning for Lincoln Massachusetts*. Using 23 assessors' maps, Adams prepared a map of the wetlands and outlined parcels of dry land around them to join the entire town with a network of trails. (Courtesy of the Kim Johnson collection.)

Bob Lemire was a major force in open-space preservation and conservation. Lemire analyzed figures from Charles W. Eliot and Morton Braun's 1958 report. With Elizabeth Snelling, town clerk, he identified a number of people many of them elderly, who owned about half of the undeveloped land. Soon, their land would be brought to market. Lemire went to the Lincoln Land Conservation Trust meeting to inform its members that these owners should receive fair market value for their land, if purchased by the trust. (Courtesy of the Bob Lemire collection.)

126

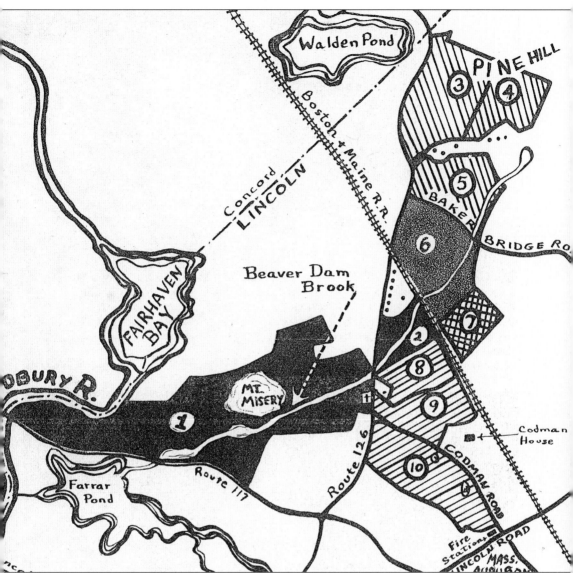

This map of the Mount Misery area was used in planning for conservation in Lincoln. In 1969, as a Lincoln Land Conservation Trust meeting was ending, Hans van Leer, who was on the County Soil Conservation District board, mentioned that for lack of use, a sum of perhaps $3 million was going back to the federal government. The board went into action and planned to acquire about 600 acres. If they got 50 percent from the federal government and 25 percent from the state government, the town reasoned that it could raise the remaining 25 percent. Their plan included Mount Misery, 122 acres of Codman land, van Leer land along Baker Bridge Road, land from Ernest Henderson on Baker Bridge Road, Pine Hill, and a piece on Baker Bridge Road from Sumner Smith. The land was appraised as 566 acres worth $1.8 million. The town approved the purchase and put the trust at the forefront of the conservation movement. (Map by Sareen R. Gerson.)

This oak tree was described by John Todd: "Yet the oak that pleases me most can be viewed by everyone traveling from Lincoln Center to the railroad station. It divides the stonewall near the eastern end of the parking area which the Codman family gave to the town. It may not be the largest oak in Lincoln, nor the most sweeping, nor the highest. Its appeal to me is difficult to define. I like it as well in the leafless season as when it is in full foliage. I can only suggest that the unsymmetrical and weather-twisted branches, silhouetted as they are against the sky, suggest strength—strength to resist the winds and elements which have swept its exposed trunk and limbs for how many scores of years." (Photograph by Herbert Gleason, courtesy of the Concord Free Public Library.)

Acknowledgments

The authors extend their gratitude to the many people who allowed access to their personal and family collections as well as to various institutions and libraries. Those names are given in the captions below each picture. The book was assembled by members of the Lincoln Historical Society: Doris Bardsley, Kerry Glass, Judy Hall, Ann Janes, Peg Martin, Bonita Robbins, and Robert Todd. Their search for photographs required great effort. Peg Martin, town historian, had initial responsibility for the captions. The staff of the Lincoln Public Library was very helpful.